BOURNEMOUTH LIBRARIES

610220349 R

D1426347

Around the World in Eighty Years

ERIC NEWBY

Around the World in Eighty Years

HARPERCOLLINS ILLUSTRATED

BOURNEMOUTH

2000

LIBRARIES

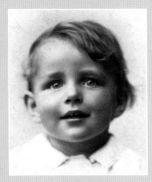

ACKNOWLEDGEMENTS

I would like to thank Lucinda McNeile,
Sarah Hodgson and Tamsin Miller at
HarperCollins; Philip Lewis, the designer,
and my granddaughter, Lucia Ashmore,
for their work on the book.

HarperCollins*Publishers*
77–85 Fulham Palace Road,
Hammersmith, London W6 8JB

www.**fire**and**water**.com

Published by HarperCollinsPublishers 2000
9 8 7 6 5 4 3 2 1

Copyright © Eric Newby 2000

The Author asserts the moral right to
be identified as the author of this work

A catalogue record for this book
is available from the British Library

ISBN 0 257223 0

Set in Quadraat

Production: Arjen Jansen

Printed and bound in Belgium by
Proost NV, Turnhout

All rights reserved. No part of this publication may be
reproduced, stored in a retrieval system, or transmitted,
in any form or by any means, electronic, mechanical,
photocopying, recording or otherwise, without the prior
permission of the publishers.

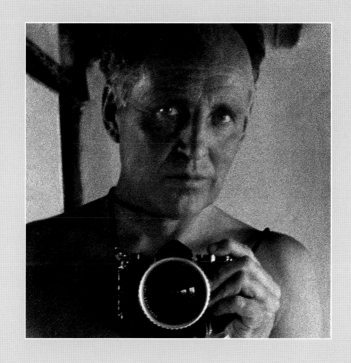

for Wanda

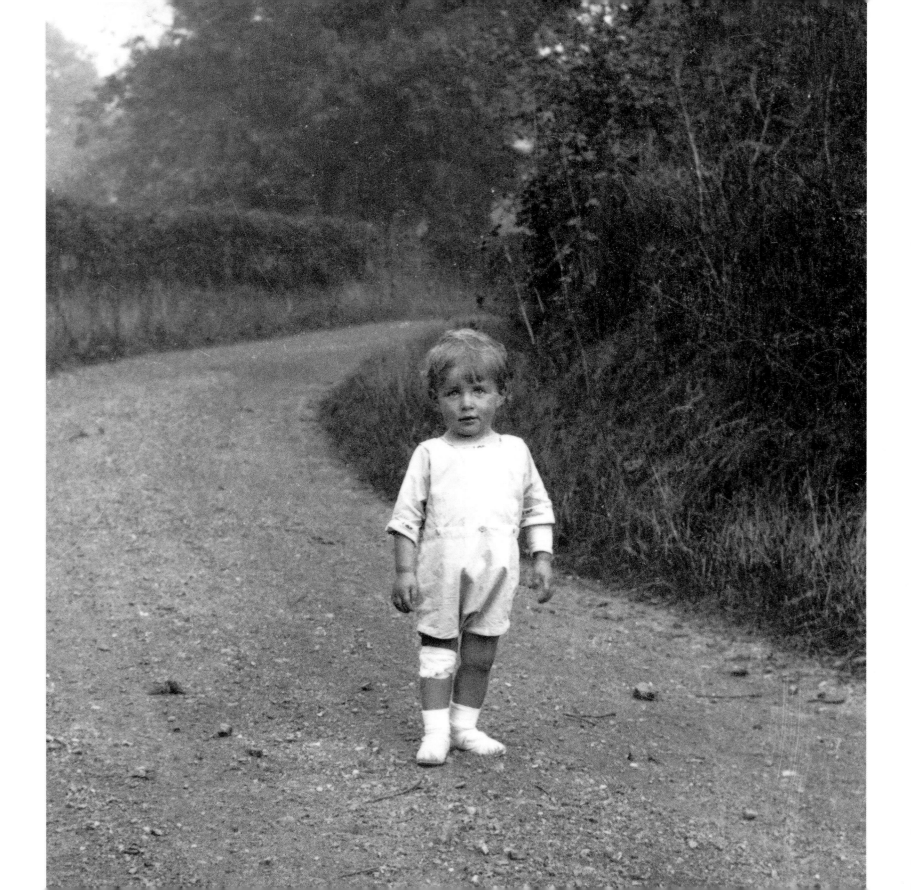

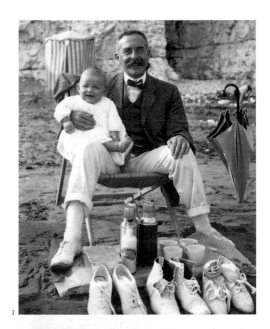

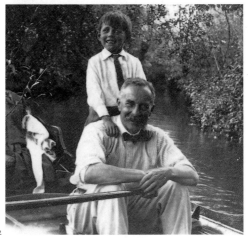

1. Myself and Father, somewhere on the South Coast, c. 1920
2. In a Thames backwater with my father, aged about seven.
OPPOSITE In a Surrey lane aged about three and a half having suffered a mishap.

To have reached the age of eighty years more or less unscathed is by no means *une affaire mince*, an insignificant matter, which is how a French friend of more or less the same age described it. How I contrived to reach sixty and then seventy without noticing it is still a mystery to me. When I was young, sixty-five was the age when bank managers (a species now becoming extinct) used to retire. They were good, clean living chaps who, in the not too distant past had played cricket and rugger on Saturdays against teams from other banks. This was the moment when, having arrived at the age of sixty-five, they were given gold watches, and in the nicest possible way told to make themselves scarce (otherwise given the chop). It was said, and widely believed, that within a year of receiving their awards – and marching orders – many of them would be dead. But being eighty-eight plus is a different matter (mince) altogether. This is the time when sprightly septuagenarians start giving up their seats to us eighty-year-olds on public transport and those who bid us 'mind how you go!' really mean it.

What was I doing when I passed through a number of 'valleys of death' unscathed? I am still trying to remember what I was up to all those years, when I could have been the recipient of a gold watch, if I had been a bank manager. Some of the time I must have been managing something myself – something I have never been conspicuously good at.

Only recently have I begun to appreciate the fascination my father must have felt when he himself was well over eighty and met a gentleman who had presented him with a visiting card on which were embossed the words 'Mr Thos. W. Bowler,' followed by an address in Walton-on-Thames which conjured up visions of a rather fine riverside house. To which my father had added the following codicil in neat pencil: 'Met on train. The originator of the Bowler Hat?' Like a man of the Renaissance my father was constantly being overcome by the wonders of the world in which he lived. Walking down a street he would suddenly glimpse some odd cloud formation, or a man with a goitrous protuberance, and without warning would stop in his tracks in order to enjoy the sight more closely.

As a result the simplest excursion made by our family resembled an extended street-fighting patrol in hostile territory, its members taking up entire streets.

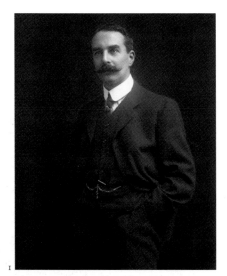

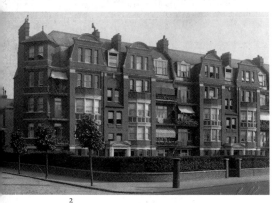

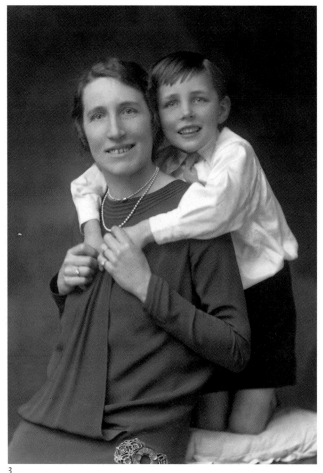

My upbringing was Victorian. My father, when he was at home, strict. If I didn't eat my greens (and I really hated them) at lunchtime on Sundays, they would appear again, cold for tea. I grew up with a strong constitution – my father saw that as an aid to victory – my bowels were kept open and my nasal passages unclogged. I was forced to sniff salt water up my nose, and to take plenty of cold baths as an aid against filthy thoughts – it doesn't work. His ambition was that I should win the Diamond Sculls at Henley. I didn't. But I did learn to scull stylishly, as did my mother, in our sumptuous double-sculling skiff which was big enough to sleep three people. My mother was very much younger than my father. She had been a model girl in my father's fashion business, and still accompanied him when he travelled, which was often.

It was also inculcated in me that work was important and that it was slightly wrong to enjoy oneself, although it didn't inhibit my father, mother and me from doing so.

It was not my father who dinned into me 'The Importance of Success in Business,' but my odious uncle – my father's brother. He was the managing director of a large department store. His Christmas present to me, when I

1. My father, unknown date
2. Castelnau Mansions, Barnes, SW13. The flats in which I was born by Hammersmith Bridge.
3. With my mother, aged eight

1. With a school friend going camping in Surrey, 1934
2. With my parents and an uncle and aunt on a South Coast beach
3. By Hammersmith Bridge, outside our flat

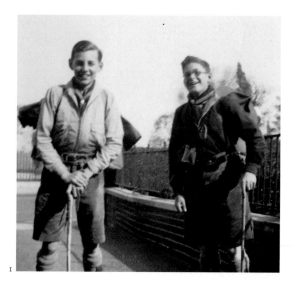

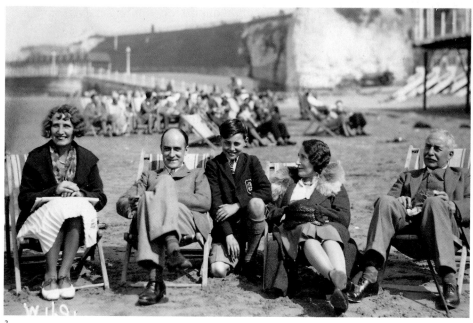

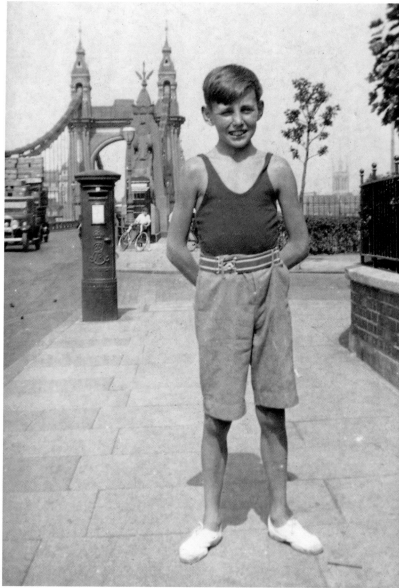

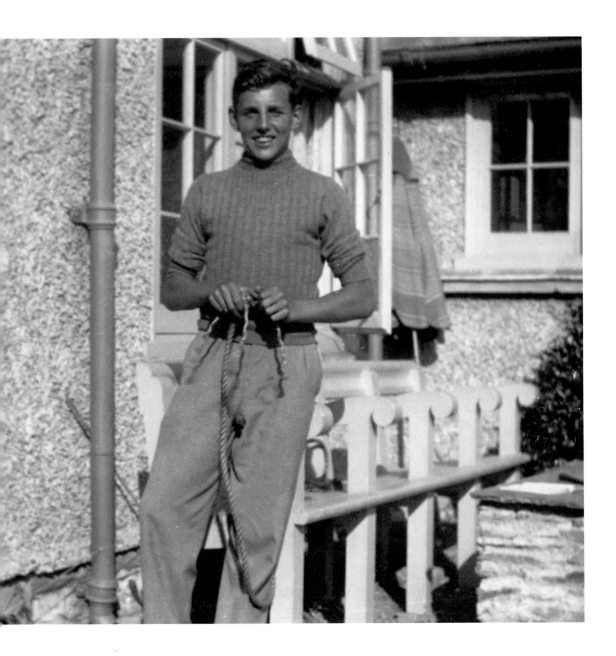

was about ten, was a book – *Lessons of a Self-made Merchant to his Son* (exhortations on how to do down the opposition and short change the customers). I told him what I had done when I put it in a wastepaper basket.

At this time I experienced a great feeling of inferiority at my inability to cope with problems of a mathematical nature which had to be solved algebraically. At that time (in the 1930s) a pass in Mathematics was obligatory. In spite of being good in History and English, I failed Mathematics. I was sixteen so my father took me away from St Pauls and put me into a fashionable advertising agency in W1. Two years later I left it to go to sea.

It is the sea that has influenced me most, although I am no great sailor, an oarsman more than a mariner. Introduce me to a sailing ship sailor who hasn't been influenced by it. There is nothing more unpredictable than a sailing ship, engineless, at the mercy of the winds and currents. And there were times when the ship would show her different faces: when she was running with 63,000 sacks of grain under the hatches, or utterly becalmed in an oily sea with turtles sunbathing around her.

The year I left school (1936) and went into advertising.

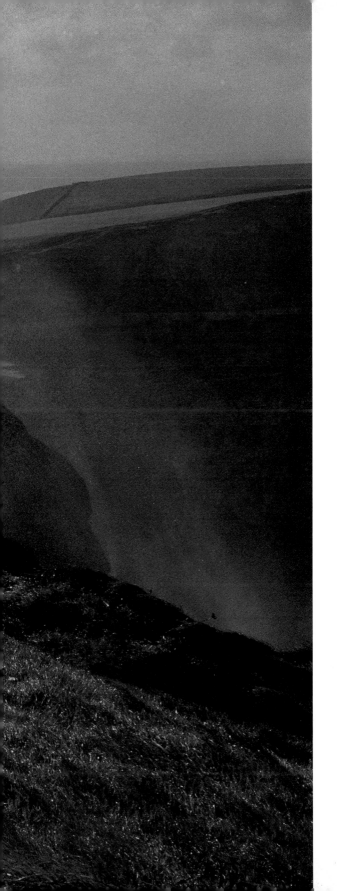

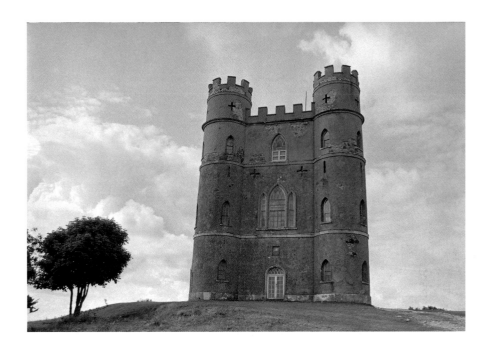

THE CLIFFS OF MOHER, CO CLARE

The cliffs, 668 feet high at their highest point, are best viewed from O'Brien's Tower. In a gale with the wind setting strongly on the cliffs, and carrying the spray of the sea and the waterfalls up the face and over the edge, there is no more awe-inspiring place in all Ireland.

THE HALDON BELVEDERE, DEVON

Four miles south-west of Exeter, this castellated, grey stone folly tower, high on a hill, was built by Sir Robert Palk (whose name was given to the straits between India and Ceylon) and is all that a usable folly should be. It has a bizarre room on the ground floor and a spiral staircase to a roof with three turrets and splendid views. Very Gothicky!

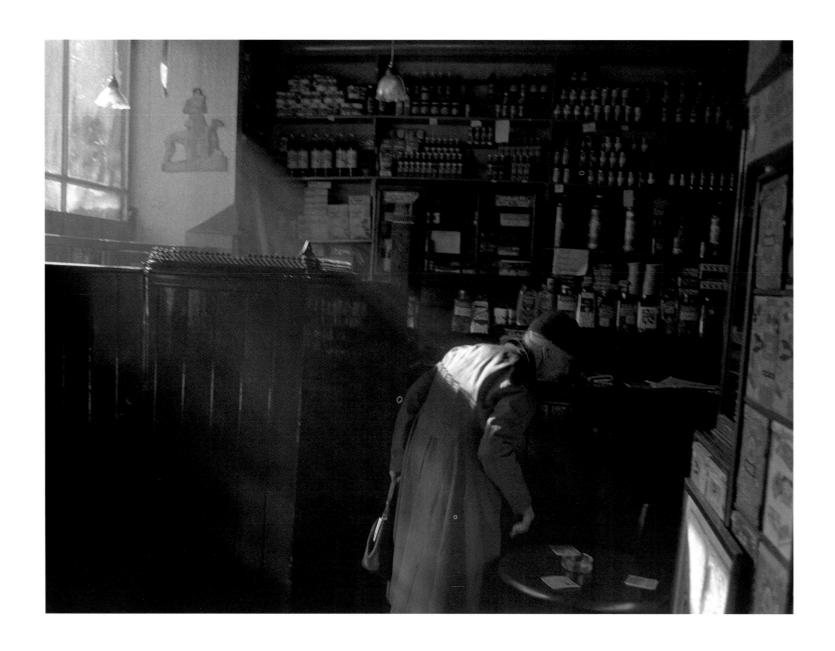

An elderly lady collects her guiness

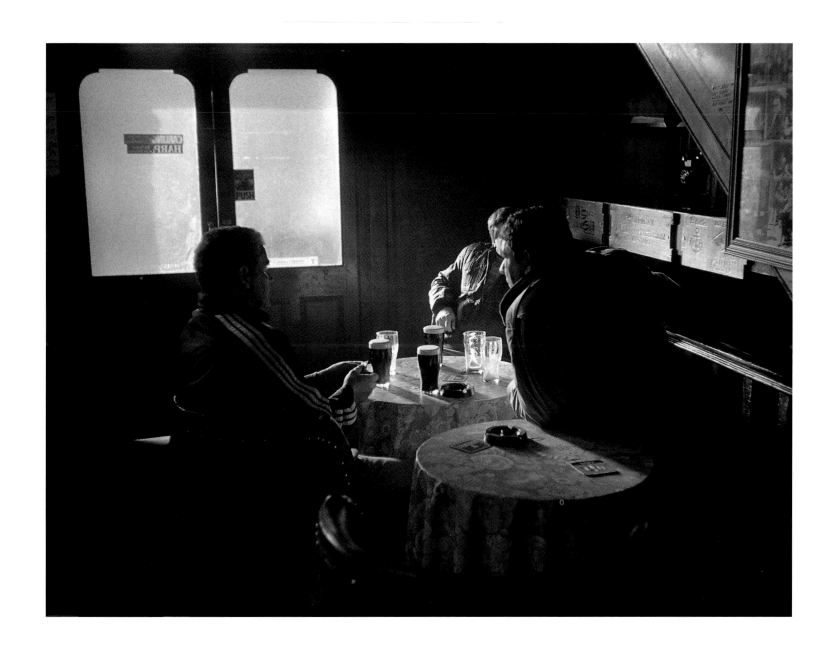

An Irish interior

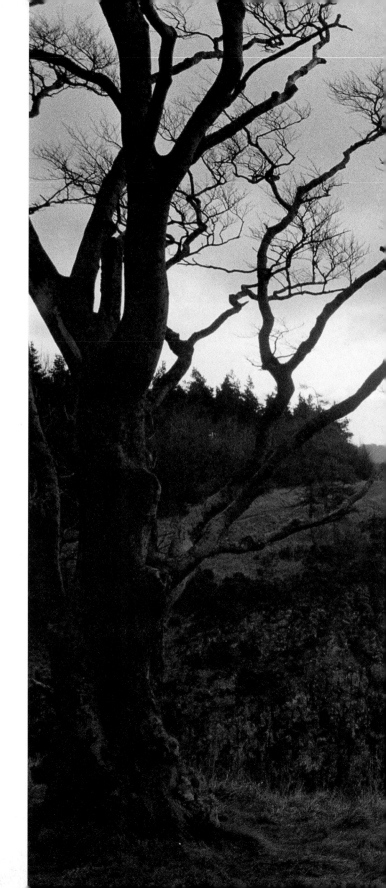

KINNOULL HILL, PERTHSHIRE

East of Perth; the view from the cliff edge should
satisfy the most romantic vertiginous taste. In the
foreground, on the mossy, tree-clad cliffs, stands a
ruined tower built by the ninth Earl of Kinnoull in the
eighteenth century, in emulation of a Rhine castle.
Further along the side of the hills there is another
tower. Far below, the Tay winds its way to the sea.
From the summit itself there is a splendid panorama
of mountains. The summit is about ten minutes'
climb through woods of oak, birch and conifer.

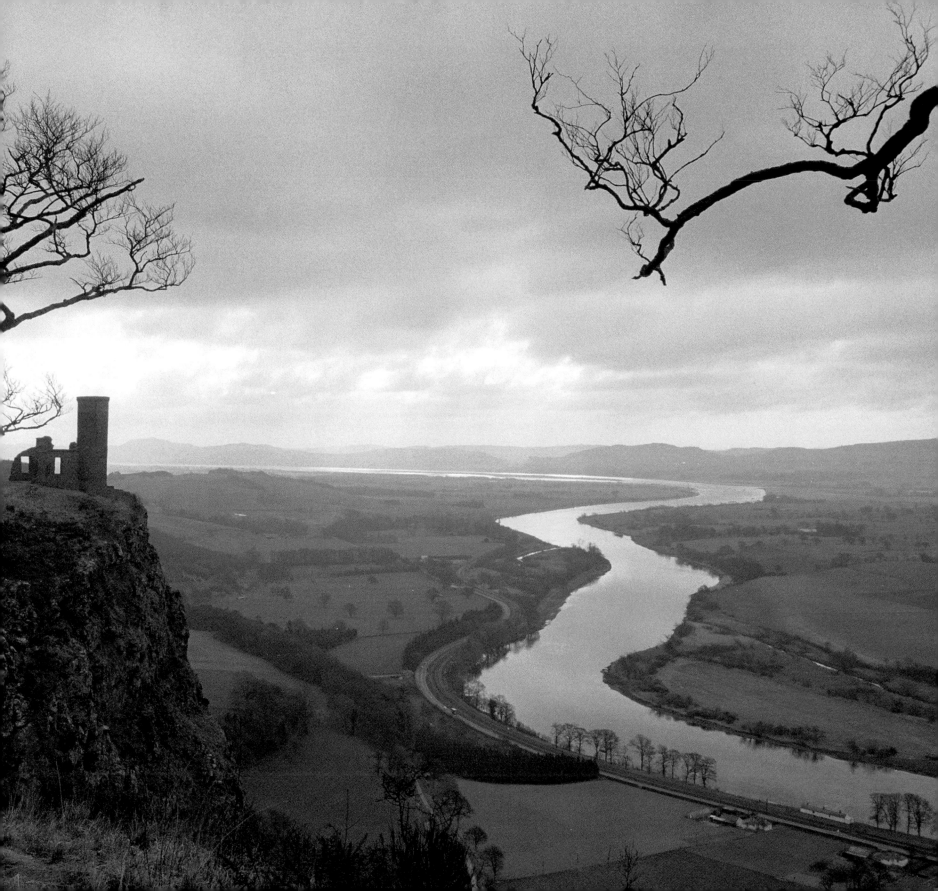

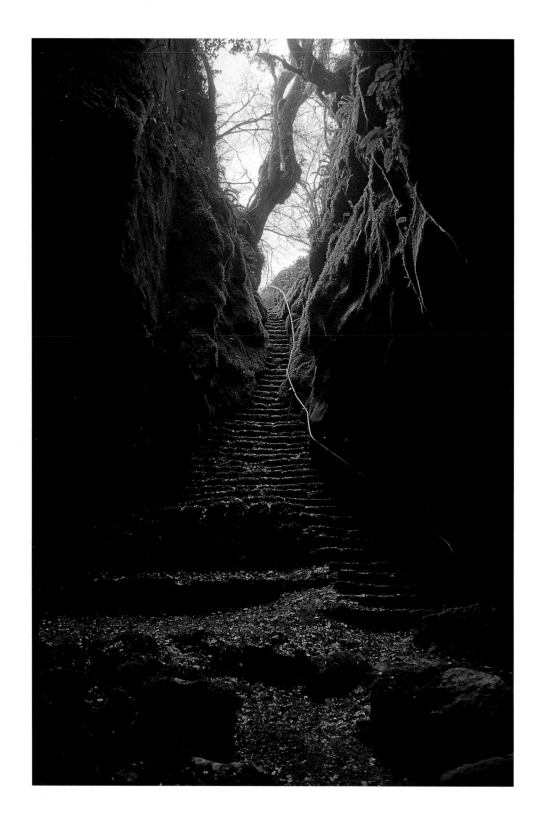

TOBER TULLAGHAN – ST PATRICK'S
WELL, CO SLIGO.

At the eastern end of the Slieve Gamph
Mountains, lies a wonder of early Christian
Ireland, because the water in it is said to ebb
and flow with the tides of the sea.

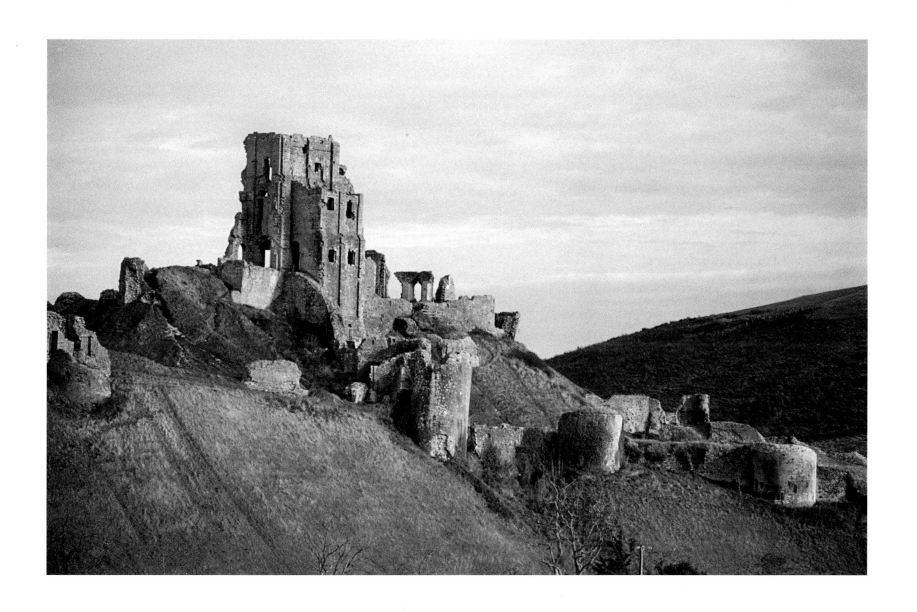

The amazing remains of Corfe Castle seen from the west. One of the finest medieval military monuments in Europe, here filling a gap in the Purbeck Hills in Dorset. A Cavalier stronghold, besieged during the Civil War, from 1642 to 1649. It was 'slighted' by the Roundheads after having been taken by treatchery – its towers had large charges of gunpowder exploded beneath them which caused them to slide a few feet downhill without disintegrating when the siege ended.

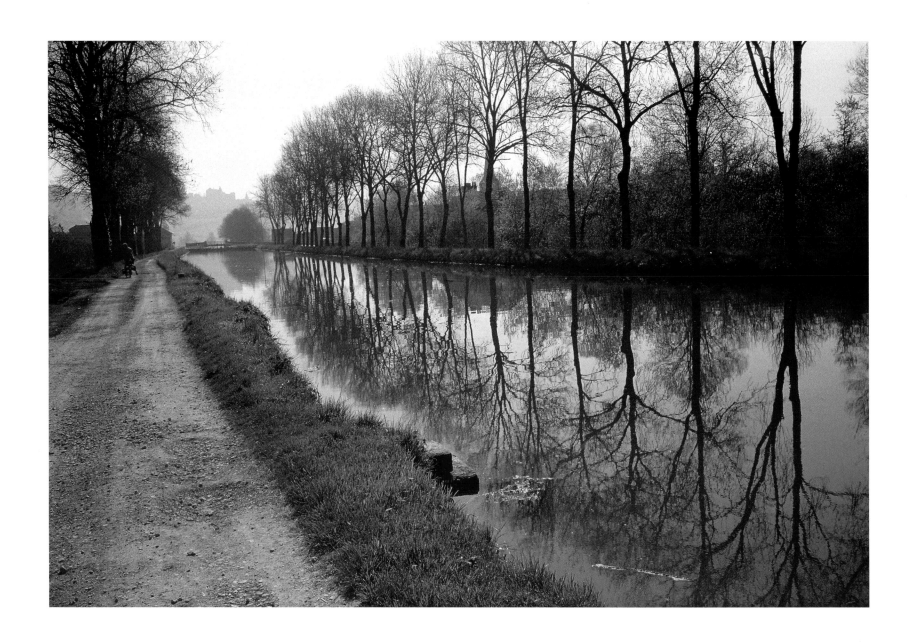

Canal de Bourgogne

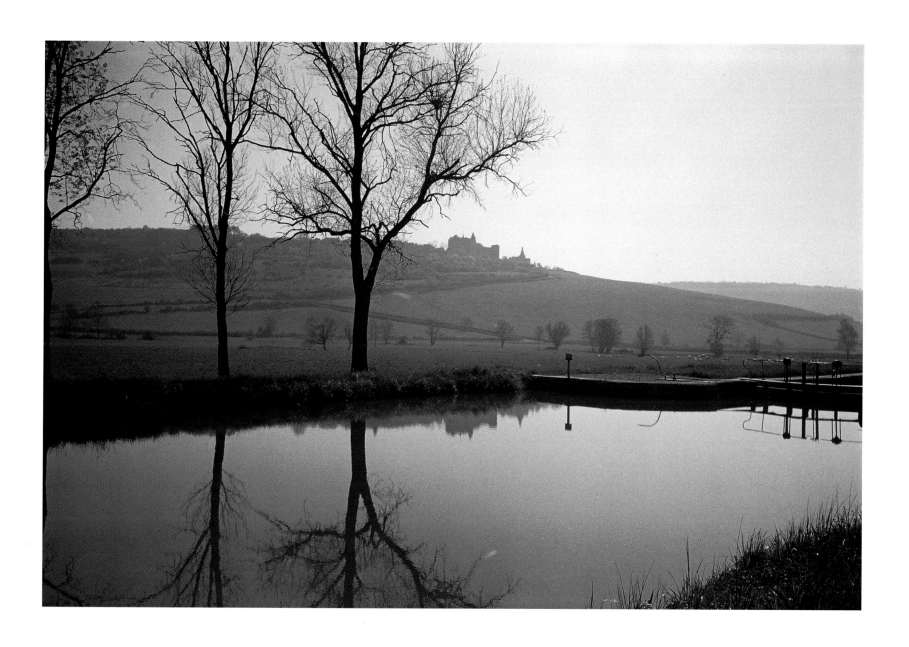

It took three days on bicycles to follow the Canal de Bourgogne up past its locks to the 378 metre summit at Pouilly-en Auxois, a place with a name that makes you think that it must have a wonderful little restaurant; well, it hasn't.

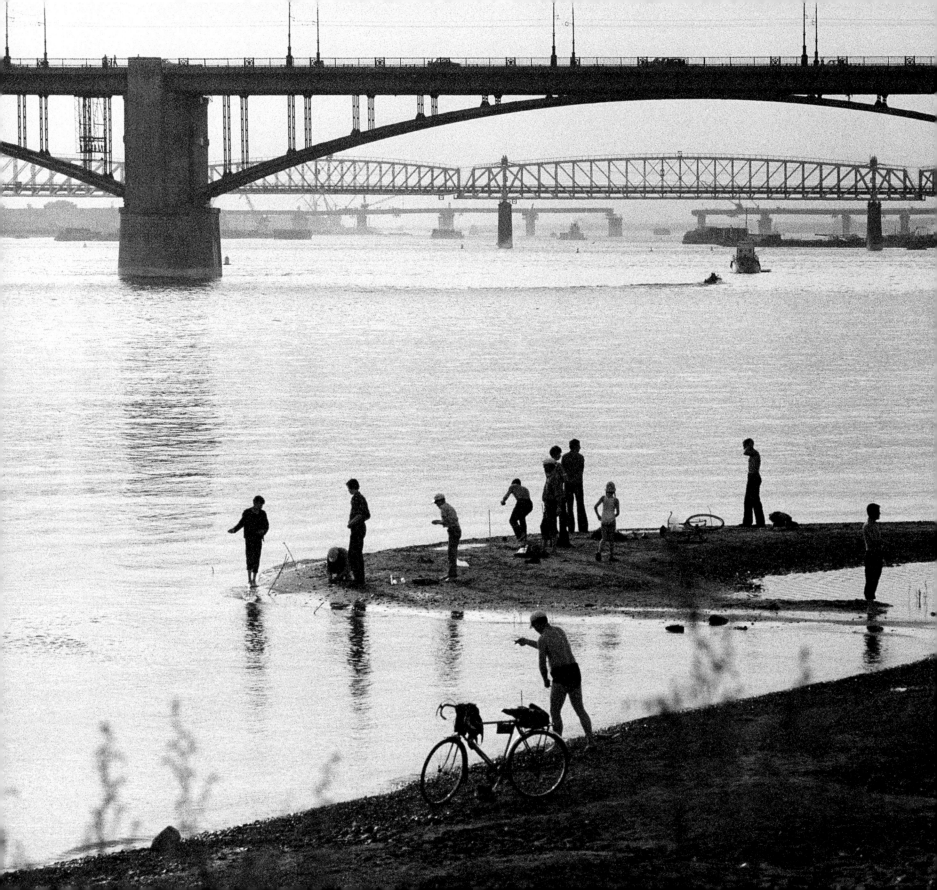

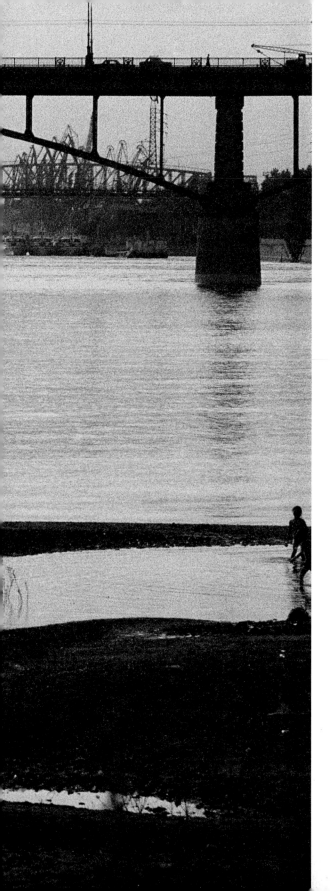

THE TRANS-SIBERIAN RAILWAY

The Trans-Siberian Railway as it was back in 1977, when we travelled on it, was the only continuous land route from Western Europe to the Pacific Coast of the USSR. In the course of this immense journey it crossed nearly 100 degrees of longitude in Europe and trasversed seven time zones. By the time it reached the Pacific it was seven hours ahead of Moscow time, but had observed Moscow time throughout the route, as had all the clocks on the stations. The journey for a Soviet citizen took seven twenty-four hour days, or to be more precise 170 hours and 5 minutes if the train was on time, to cover the 5810 miles from Moscow to Vladivostok on the Sea of Japan where it arrived soon after noon on the eighth day. Foreigners were not allowed into Vladivostok, in case they might espy some more modern version of the battleship Potemkin. They had to go on to Nakhodka, at that time the only Soviet port facing the Pacific that was open to them. From which they could take a ferry to Japan – a distance of 5900 miles. The journey consumed almost eight twenty-four hour days – 192 hours and thirty five minutes, which included a stop from day seven to day eight at Kharbarovsk on the Amur River, once a runner up as the site of Armageddon. Here you changed trains for the last, exciting lap along the frontier with China. The train reached Nakhodka on the morning of the ninth day. There is no railway of comparable length anywhere in the world. Even New York – Los Angeles on the *Sunset Limited* is a mere 3420 miles. The Trans-Siberian is *the* Big Train Ride.

LEFT The Ob river at Novosibirsk

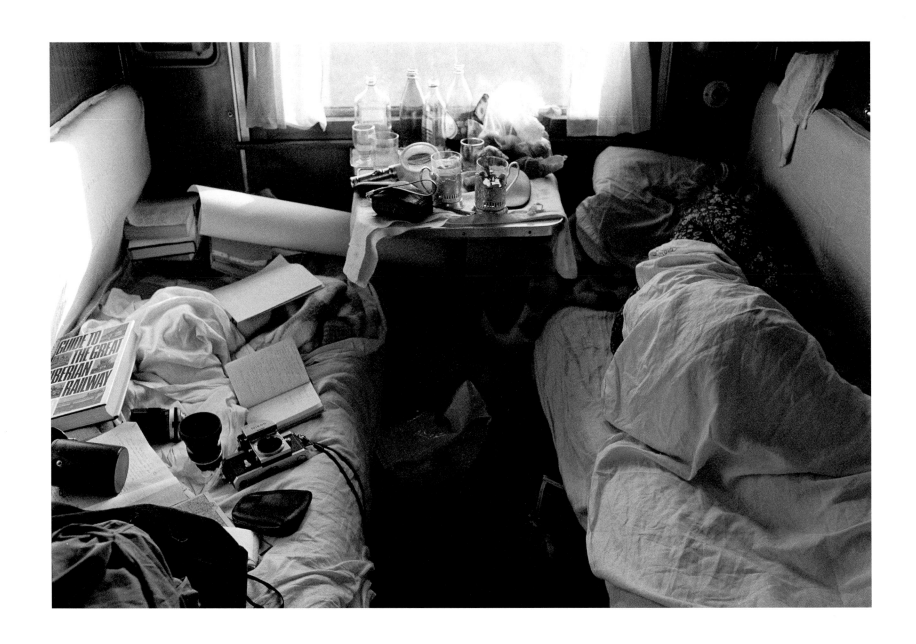

The Newbys' compartment on the Trans-Siberian Railway

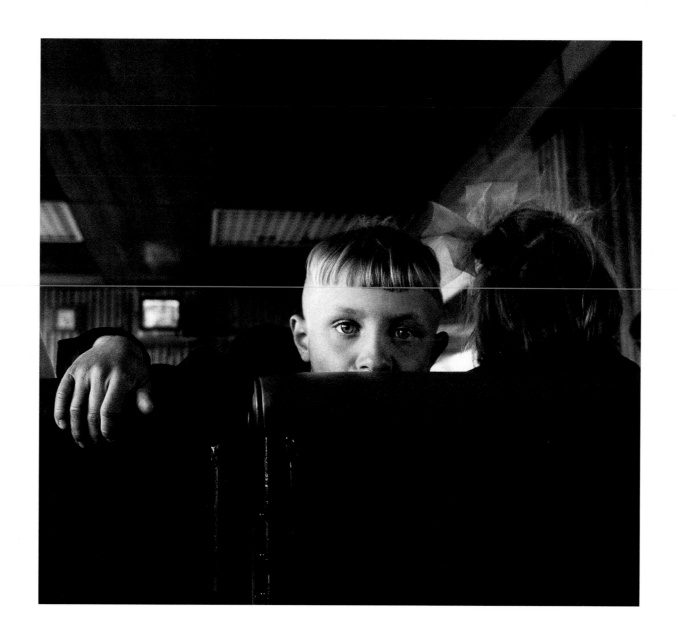

Hard seats on the Trans-Siberian Express made kneeling more comfortable

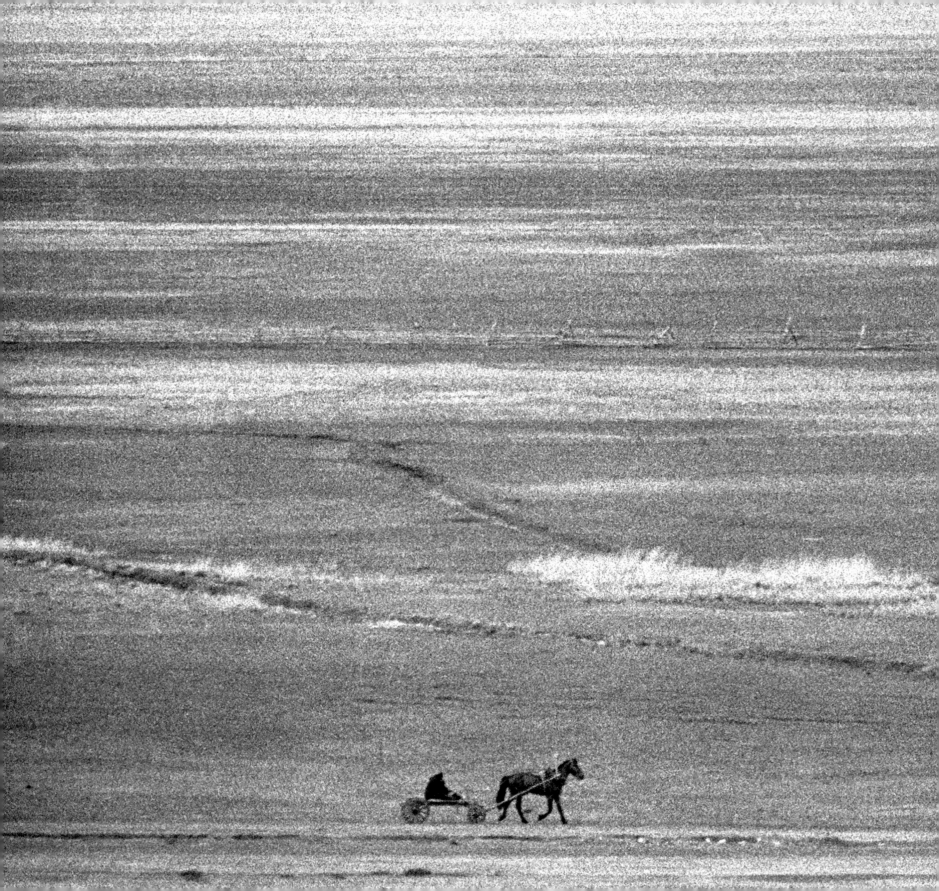

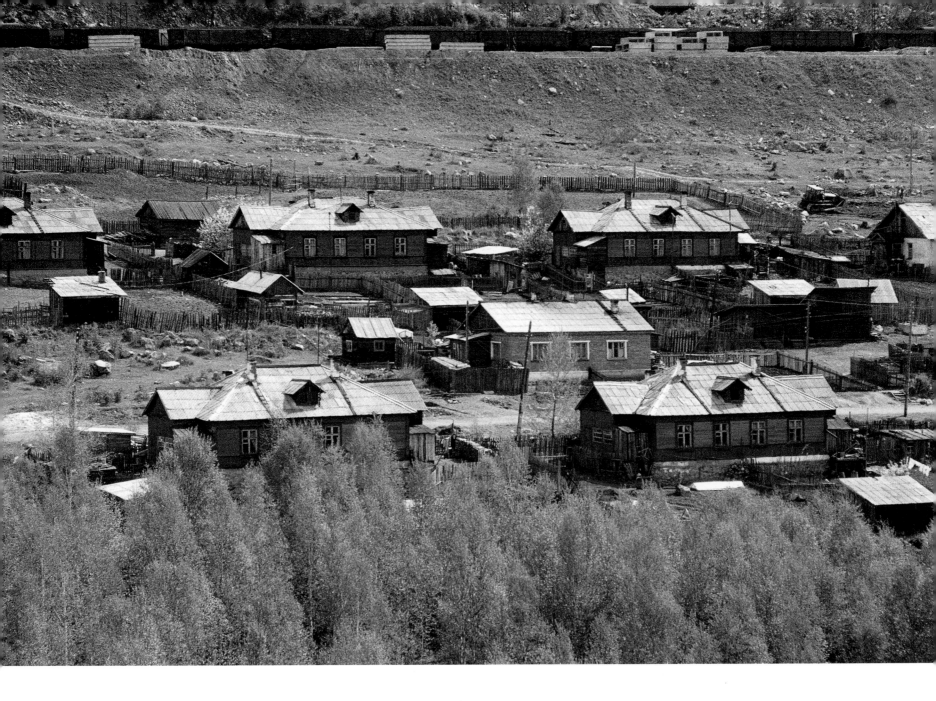

Small town beside the railway on the way to Lake Baikal

PREVIOUS PAGE Horse and cart on the Buryat Steppe,
eastern Siberia

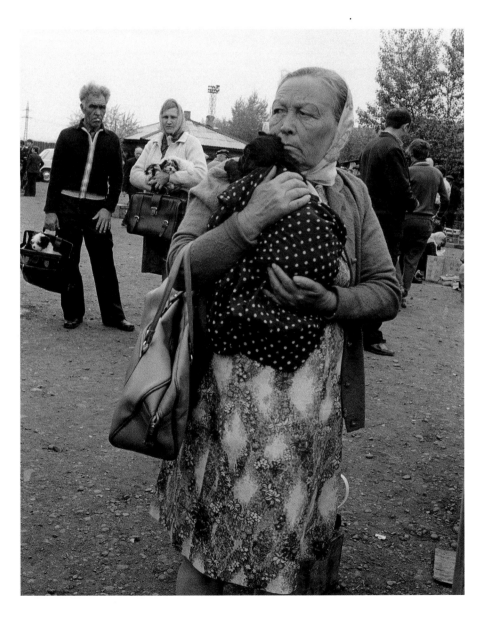

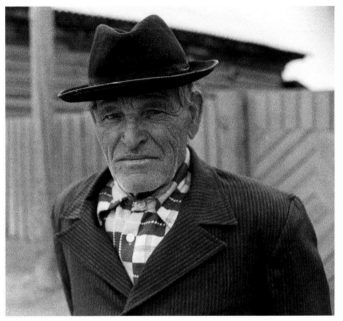

ABOVE Man with a hat, Buryat Steppe, eastern Siberia

LEFT Lady with a purchase at a pet market in Baikal

41

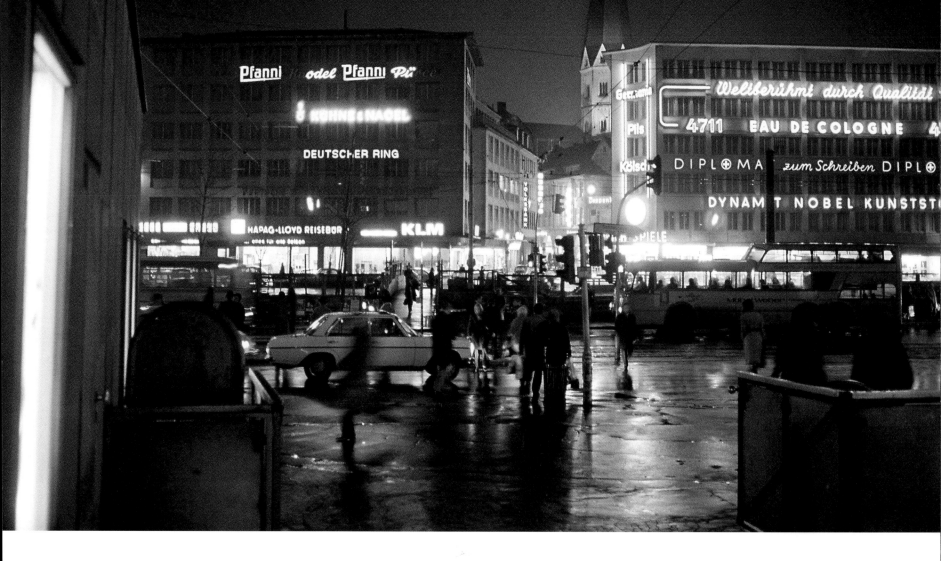

Christmas Eve in Bonn

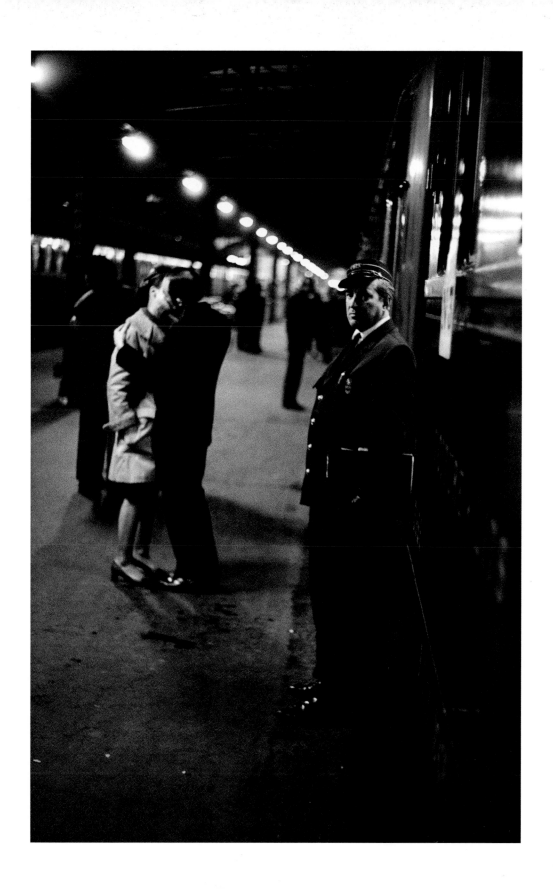

Night train from Istanbul

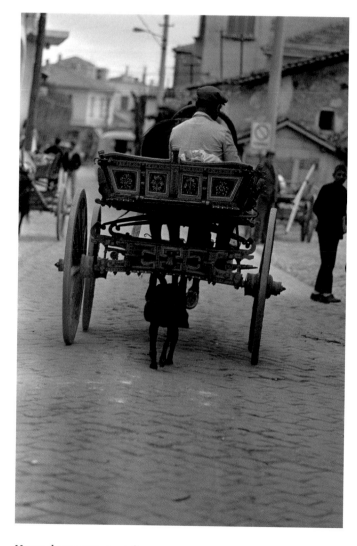

Horse-drawn cart, Anatolia

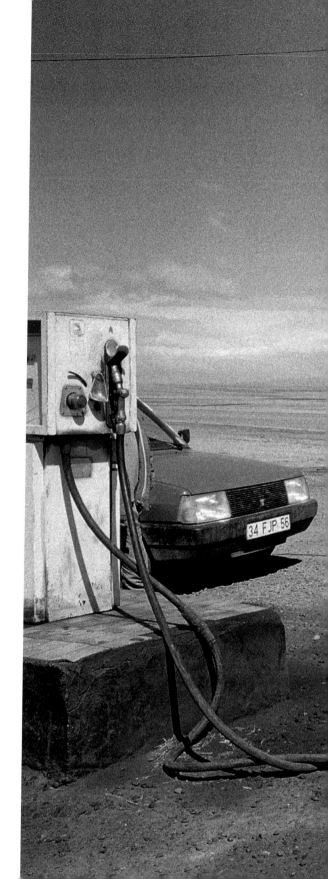

RIGHT Petrol station, Anatolia

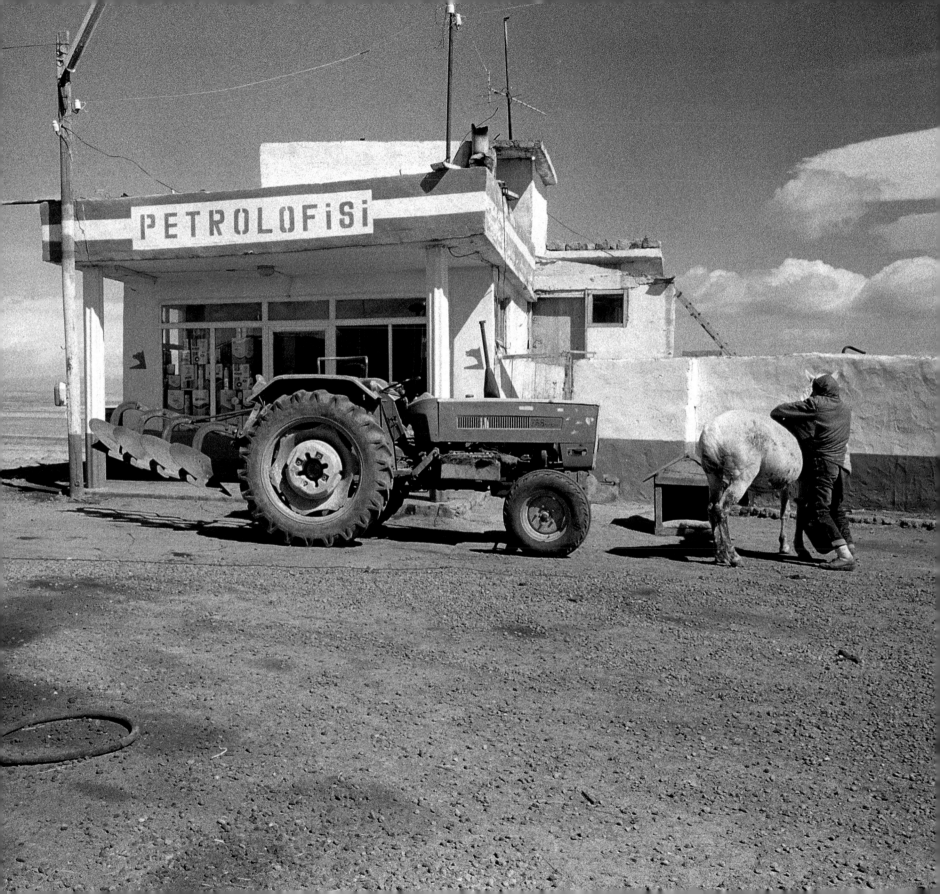

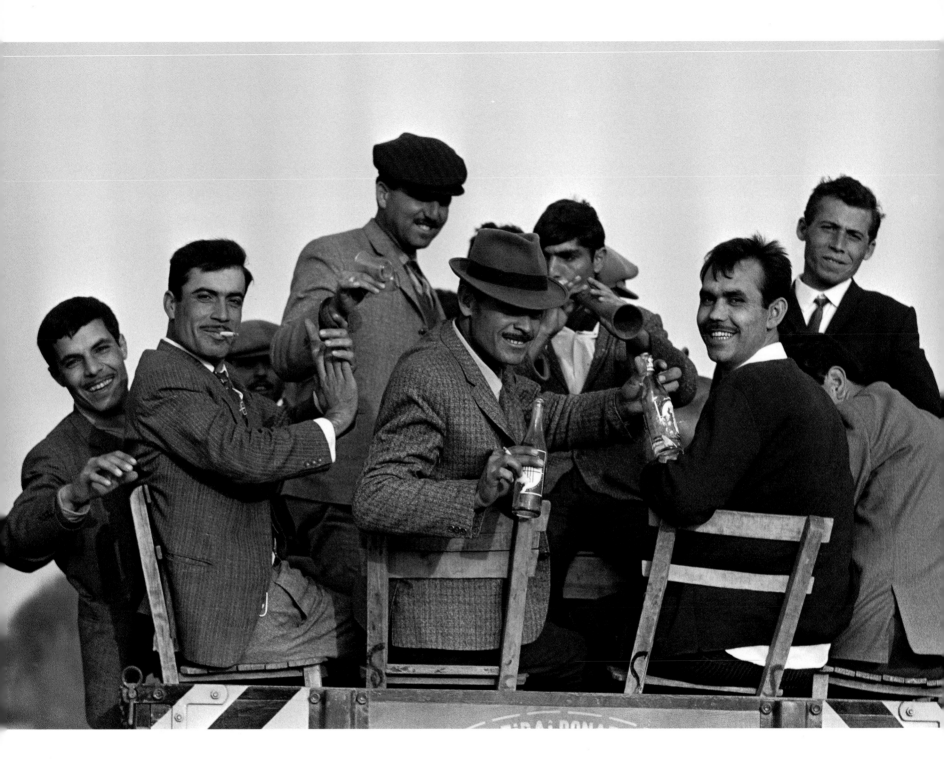

Turkish guestworkers returning from Germany

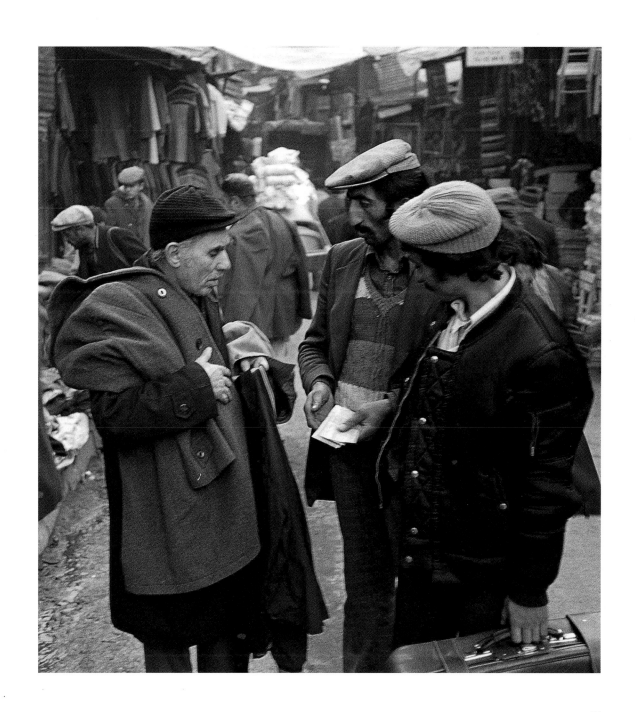

Istanbul, in the approaches to
the Great Bazaar

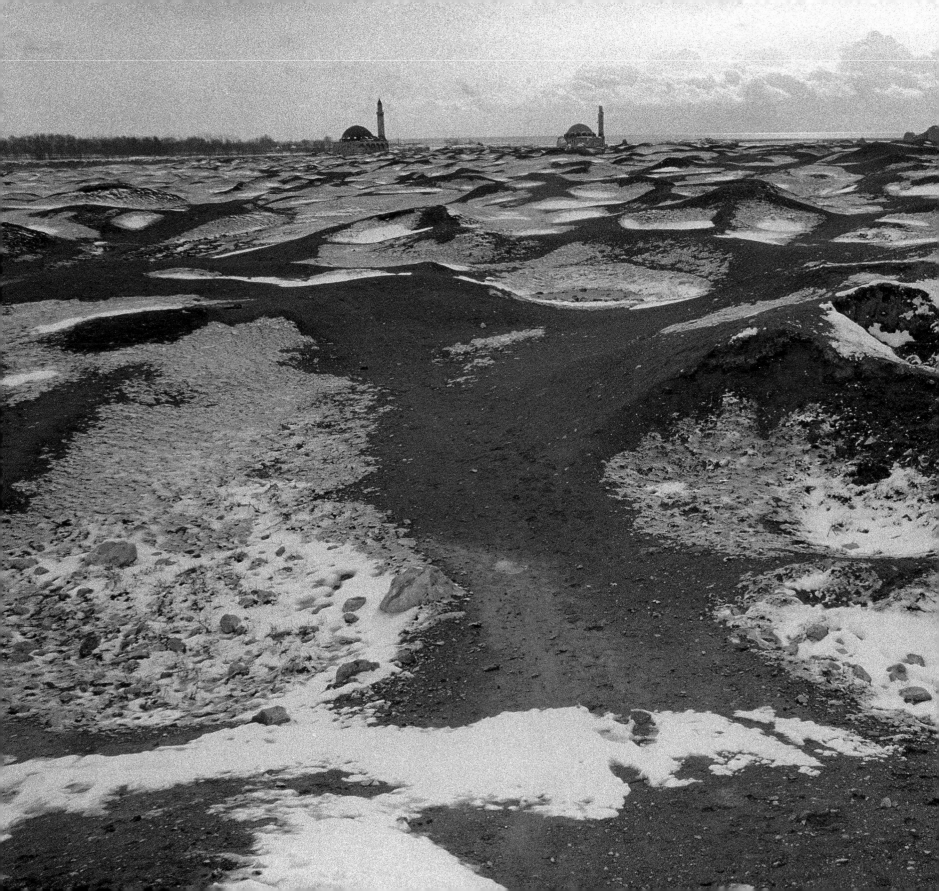

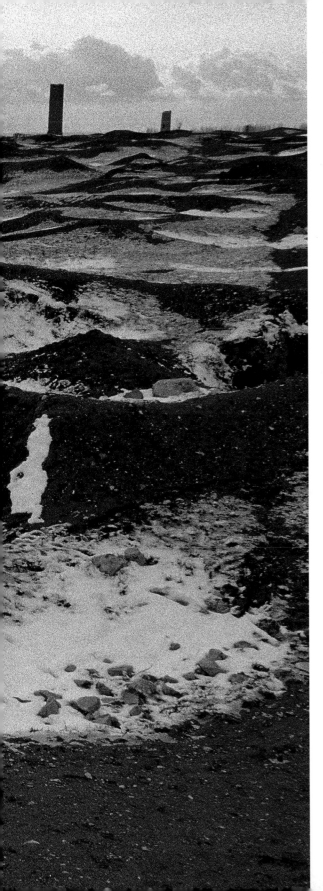

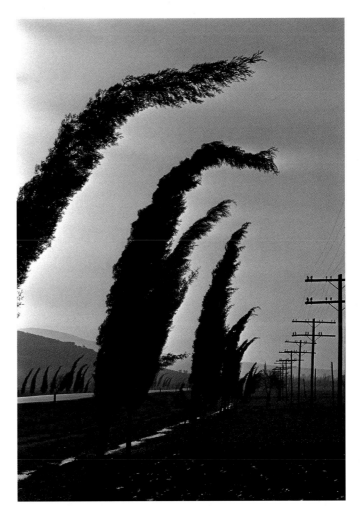

Gale in Anatolia

LEFT KARS, UNDER THE SNOW

The beginning of the end of Kars was in 1915 when the Armenians
in the walled city below the citadel were besieged by the Turkish
Army. Then it was captured and lost again by the Russians, who
finally held it from March 1917 until the Armistice. Now, in 1991,
it looked as if it had been atomised.

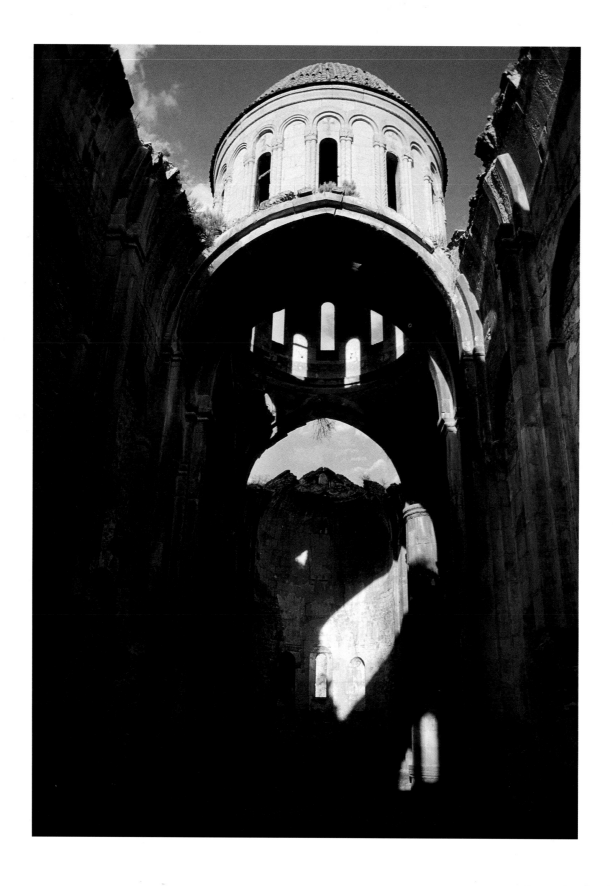

Ruin in Anatolia

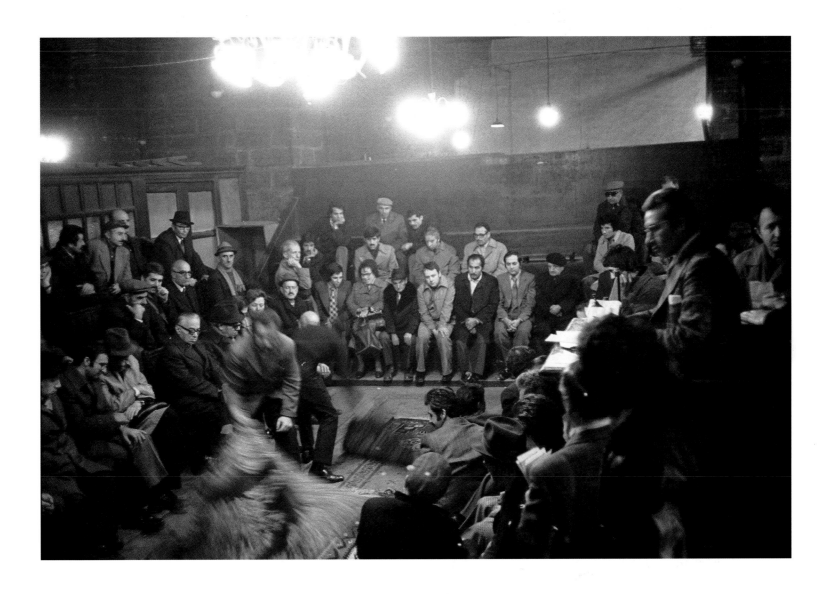

Carpet auction in the Sandal Bedesten, Istanbul, part of the Great Bazaar, now closed for business. Until the middle of the last century, when European competition wiped it out, the Sandal Bedesten was the centre of trade in rare silks, which was conducted there by the Armenians. It was originally built of wood in the reign of Mehmed II, the Conqueror, not long after he took the city in 1453. Together with the rest of the city, the bazaar has been burned down innumerable times. Rebuilt in stone, it is a huge vaulted building of almost Piranesian grandeur and until recently was used for auctions of carpets and other valuables. Here sitting on one of the curved wooden benches, you could pit yourself against Turkish and Armenian dealers, starting to buy carpets from £100 a throw.

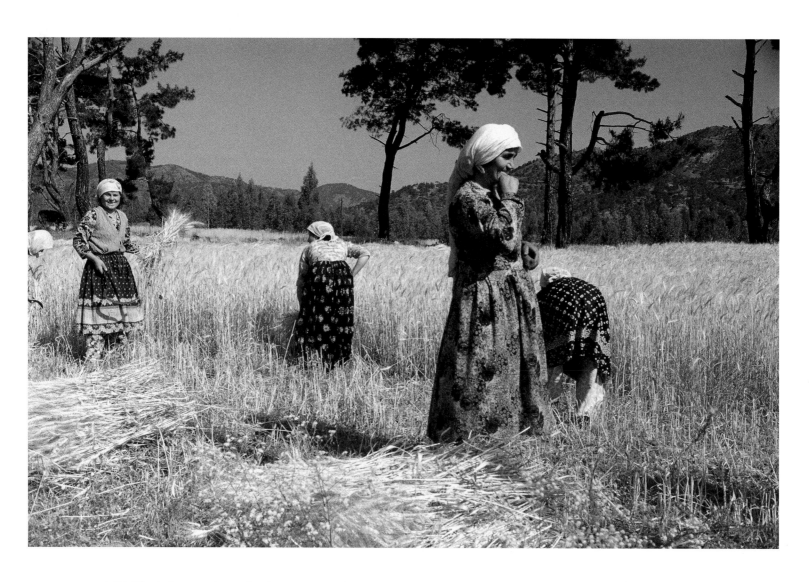

Brilliantly clad women harvesting in eastern Anatolia

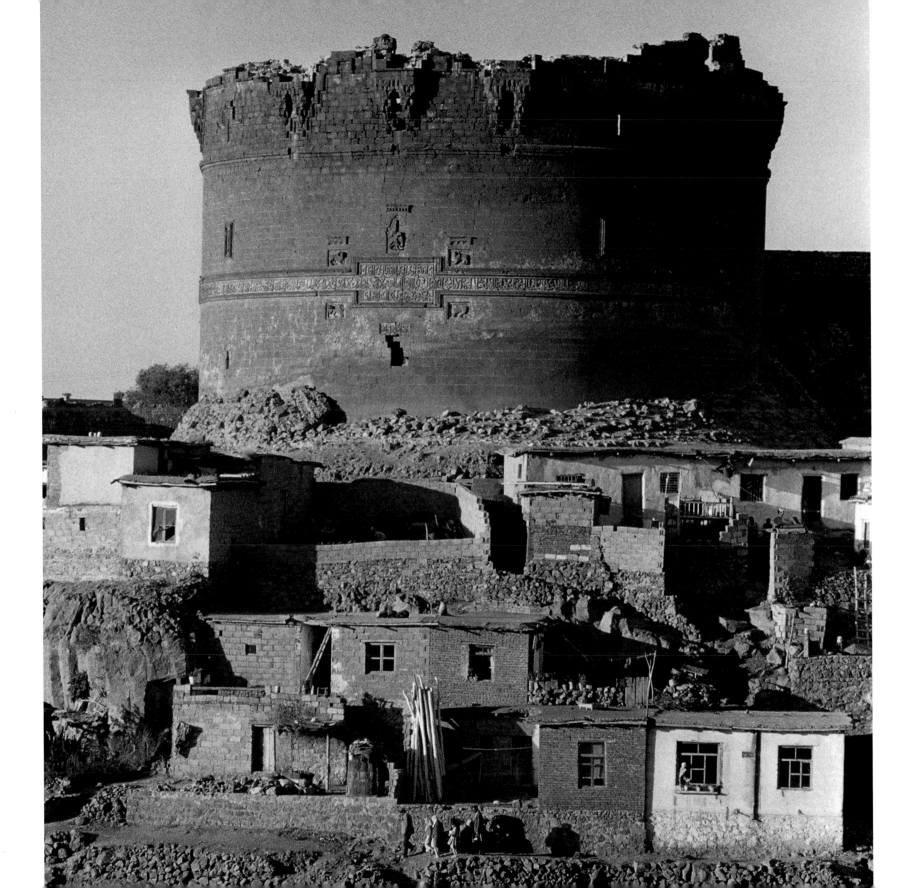

Nemrut Dagi, stone statues thrown down by
some cataclysm, now being ruined by people
climbing on them.

The summit of Nemrut Dagi in eastern Anatolia was
6,500 above the sea and the air was as clear as crystal.
Wild-looking Kurds with rifles guarded the site with
commendable ferocity against would-be thieves and
vandals, and one of the former, a tourist, was being
removed as we arrived. Here in a tent flapping in the
wind, her advanced and very exposed headquarters,
the distinguished, now elderly archaeologist,
Theresa Goell, was already at work. She and professor
E. K. Dörner were the first to carry out a methodical
investigation of the site, beginning in 1953.
Above us rose the cone-shaped tumulus more than
160 feet high and more than 48-feet in diameter,
constructed for King Antiochos I Epiphanes who ruled
over this, his kingdom of Commagene, in the first
century BC. Under it his remains are thought to lie.
Please God someone doesn't have the bright idea of
removing it in order to find out, for it is built of
millions, of smallish white stones. Now, in the early
morning, against the amazingly blue sky, it looked
incomparably beautiful. As if it were the true summit
of the mountain, covered by a heavy night frost.

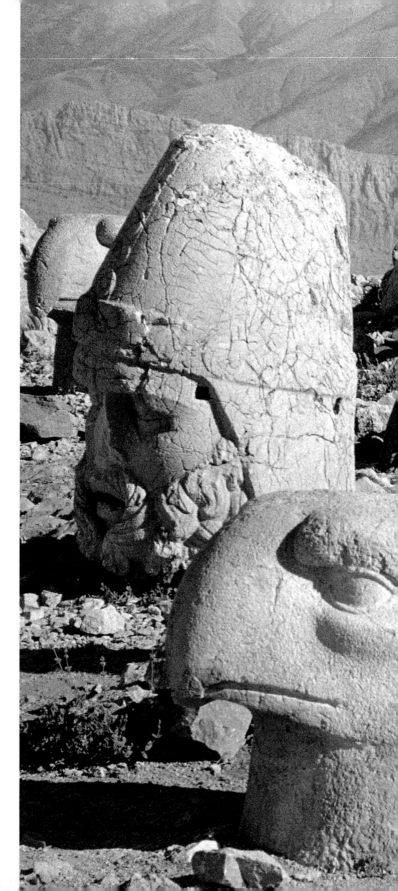

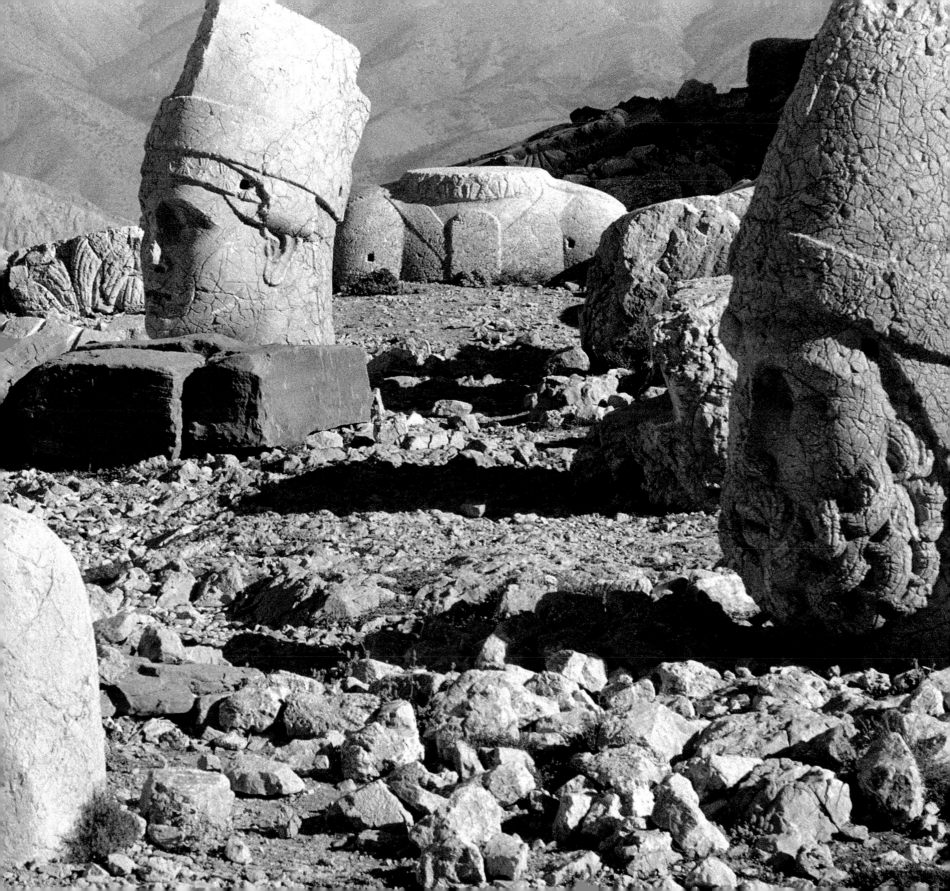

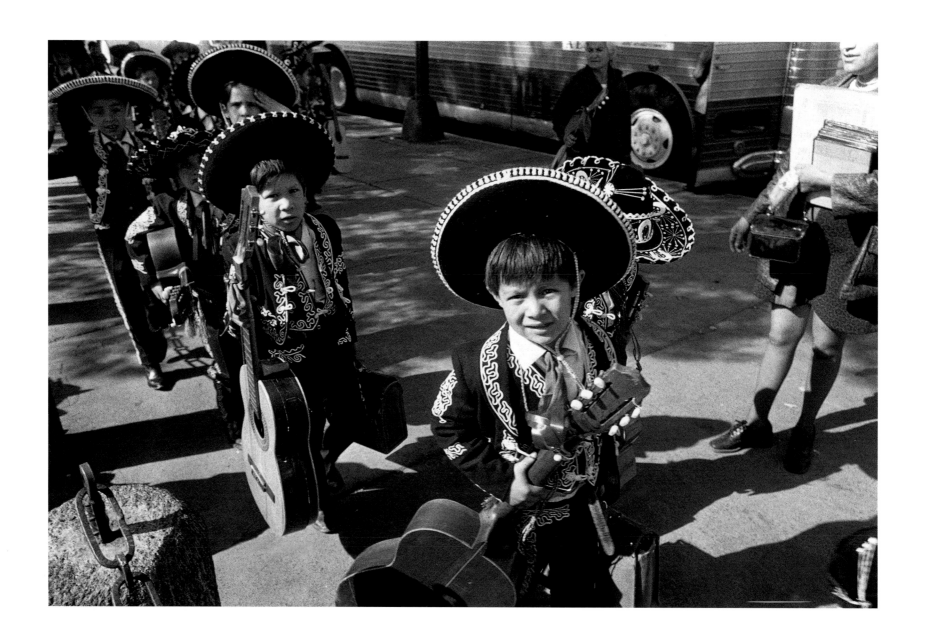

Boy band from Mexico at a festa

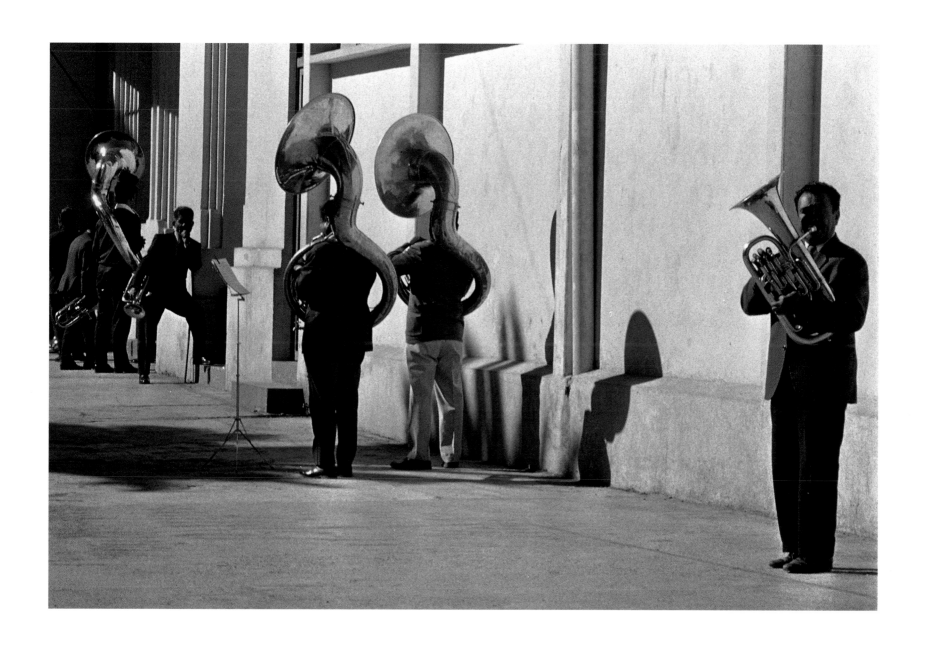

Tuning up at a festa, Mexico

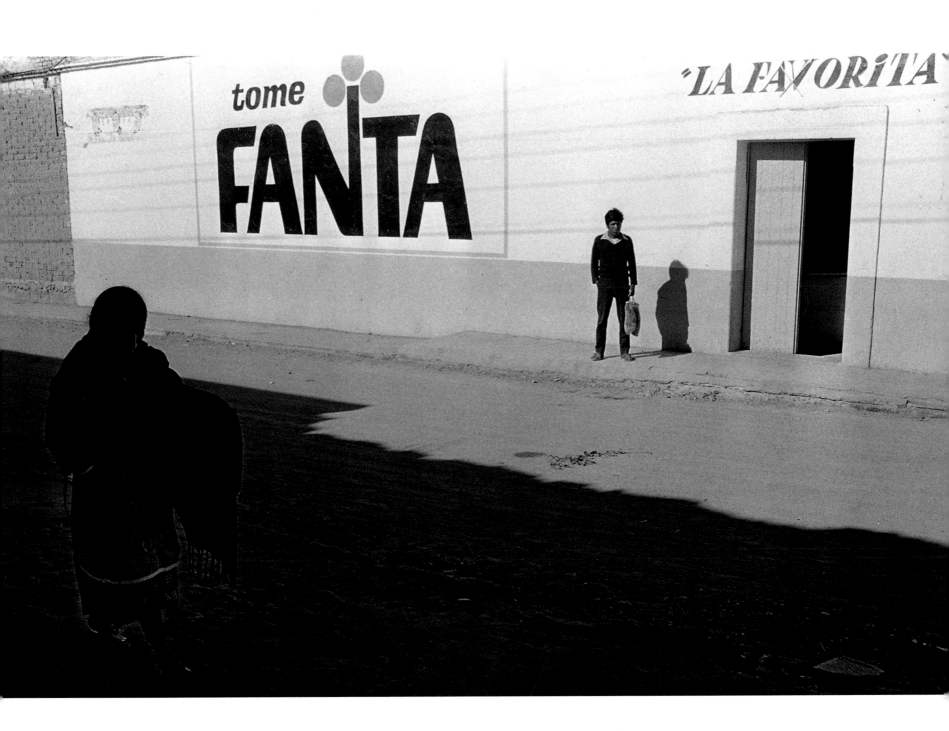

Fanta la favorita!

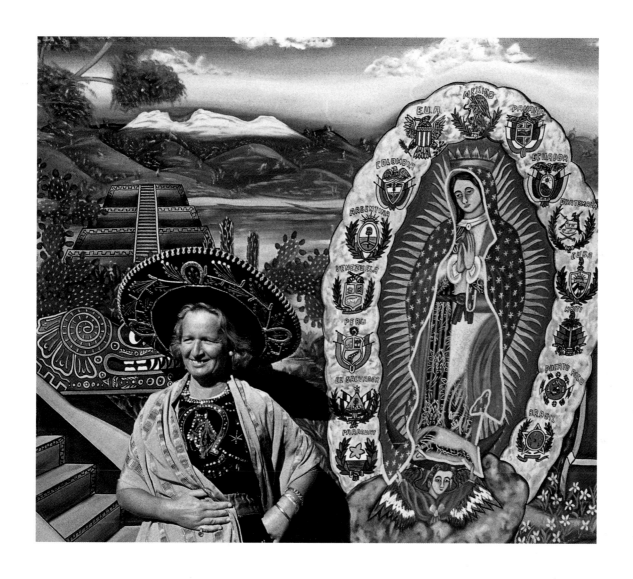

Wanda on show, Mexico

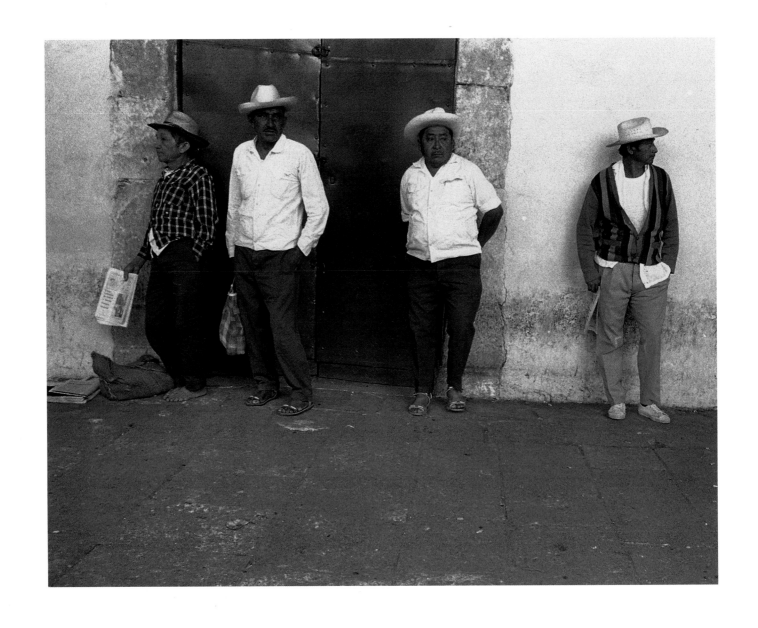

Mexico City

OPPOSITE Church in Yucatan

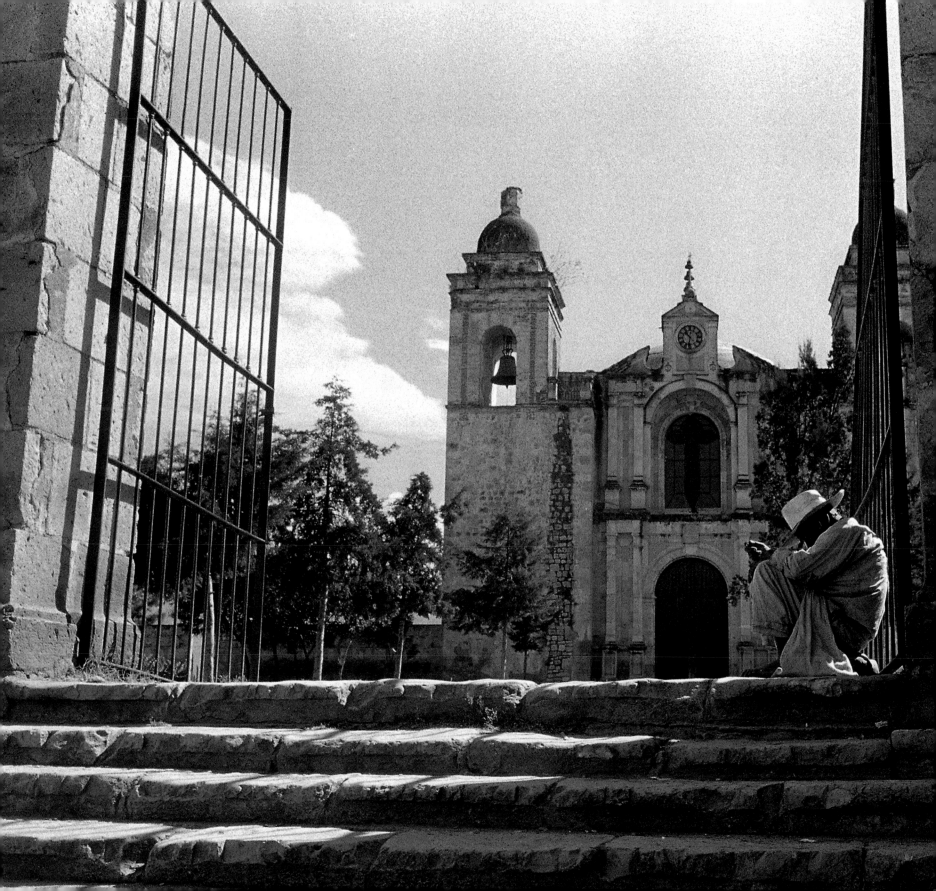

Urban development, Mexico City

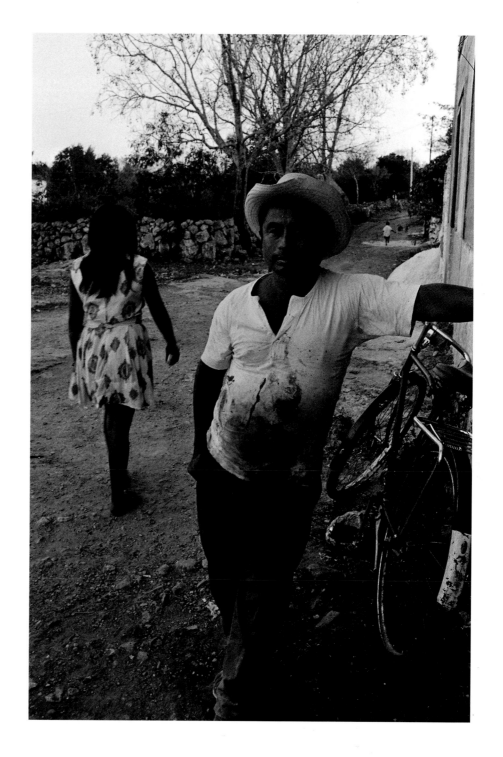

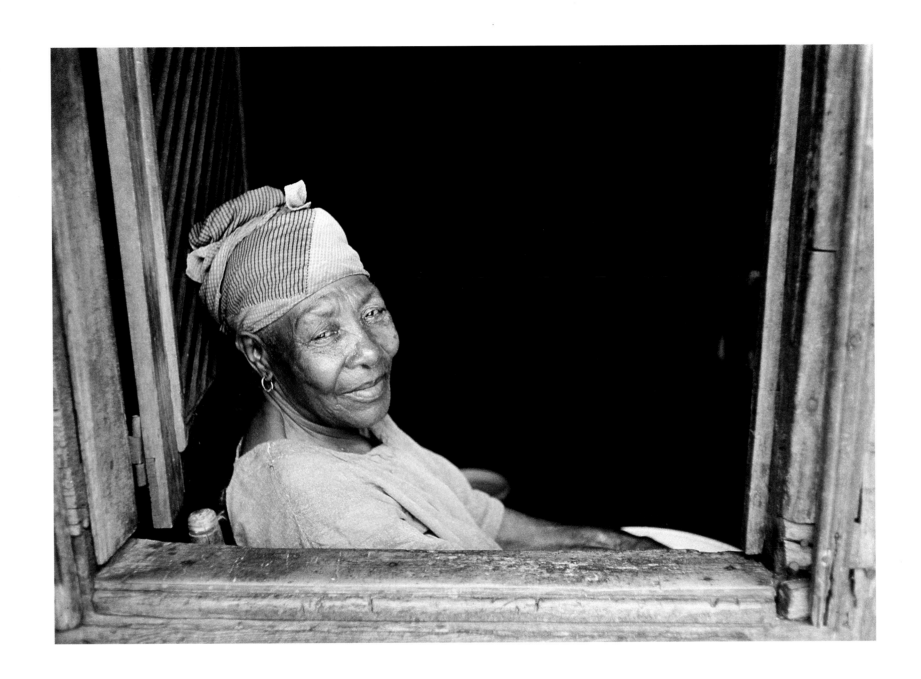

Seen through a window in Rouseau, Dominica

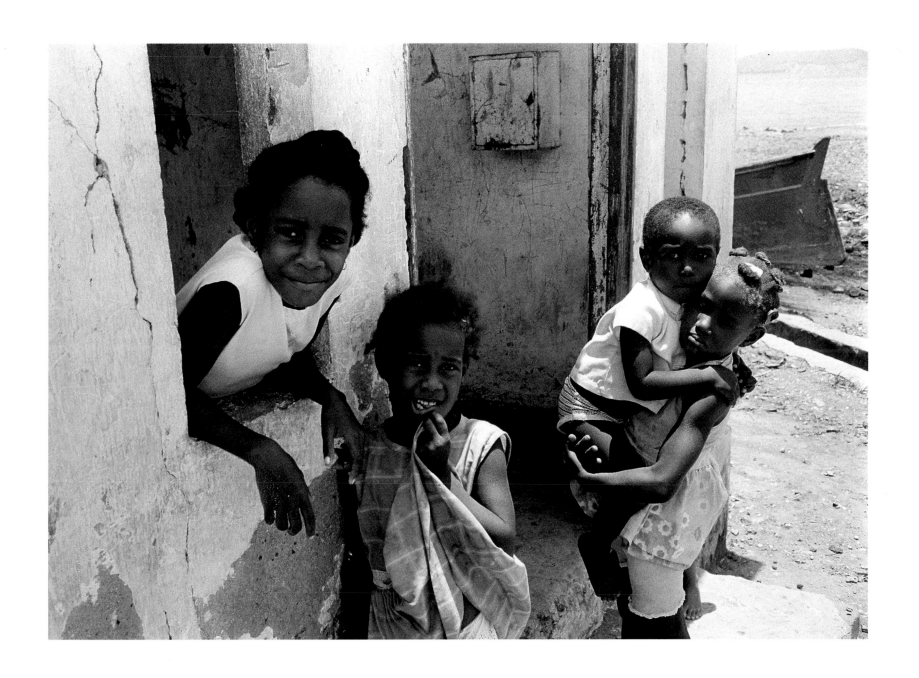

Children in Martinique

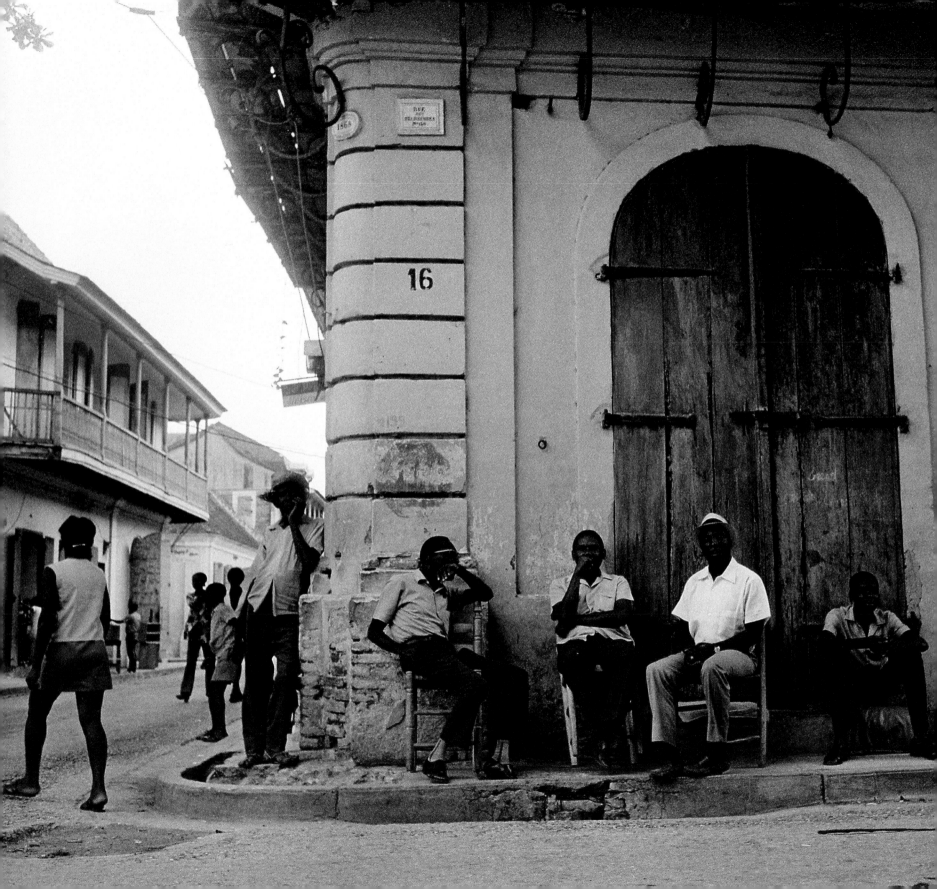

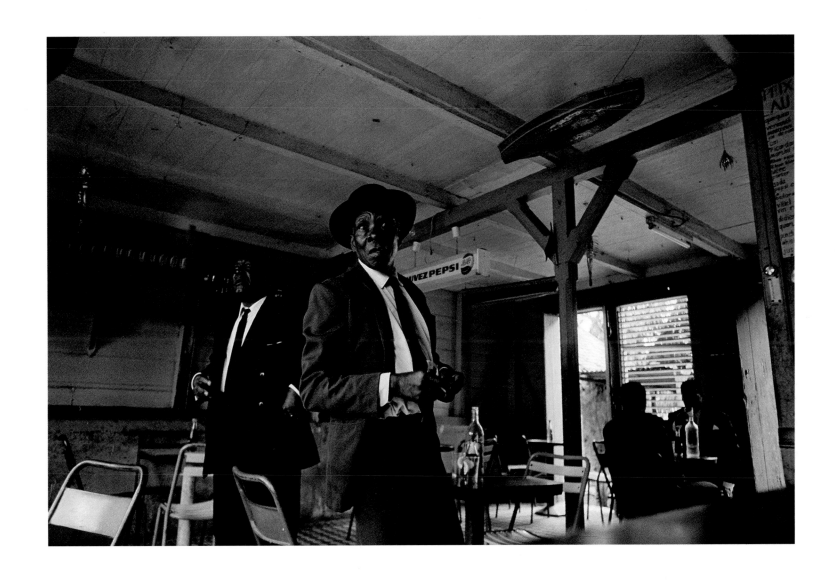

OPPOSITE Street corner, Haiti

Port-au-Prince, Haiti, at the airport we joined a queue which eventually brought us to a desk at which was perched a large man aged about fifty, wearing dark glasses, and an unreasonably thick Cheviot suit. It required little imagination to identify this senior citizen as a former member of Les Volontaires de La Sécurité Nationale, otherwise the Tonton Maccoutes. Despite Papa Doc's timely demise, the organisation remains under a cloud.

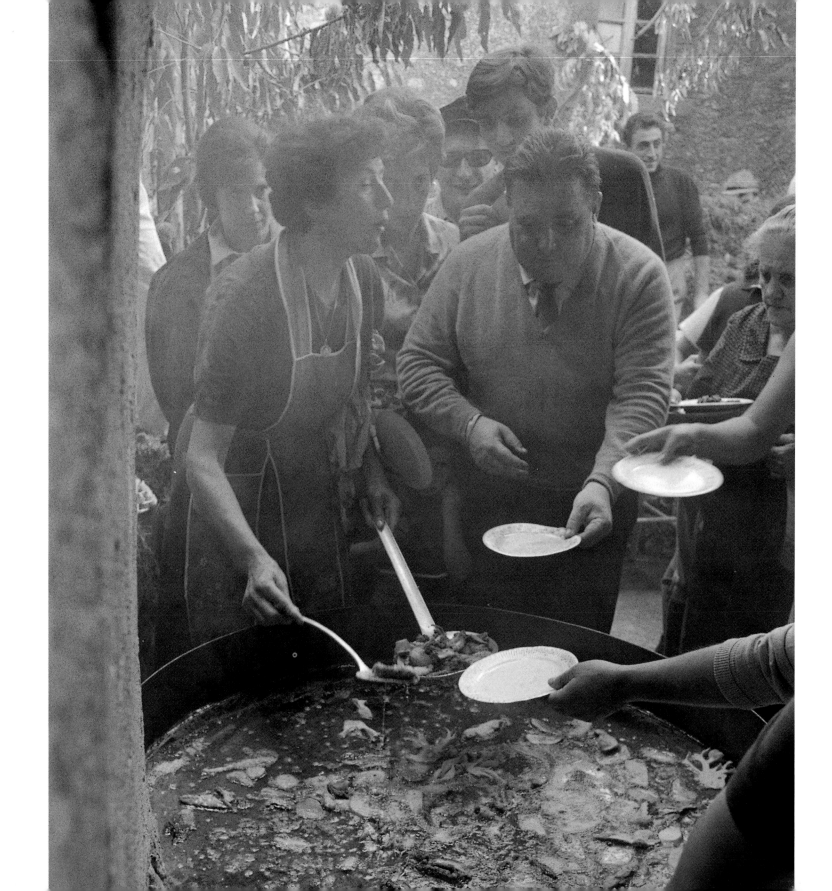

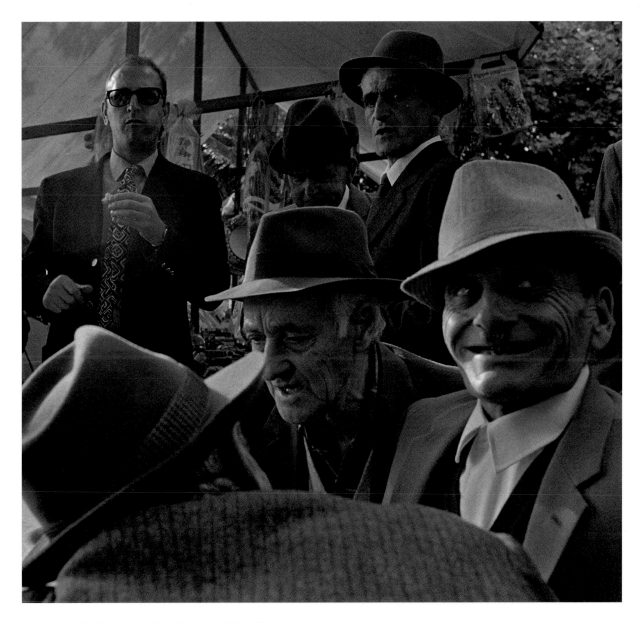

At the festival of San Remigio in the town of Fosdinovo

OPPOSITE Festa di Funghi in a village in the Apuan Alps

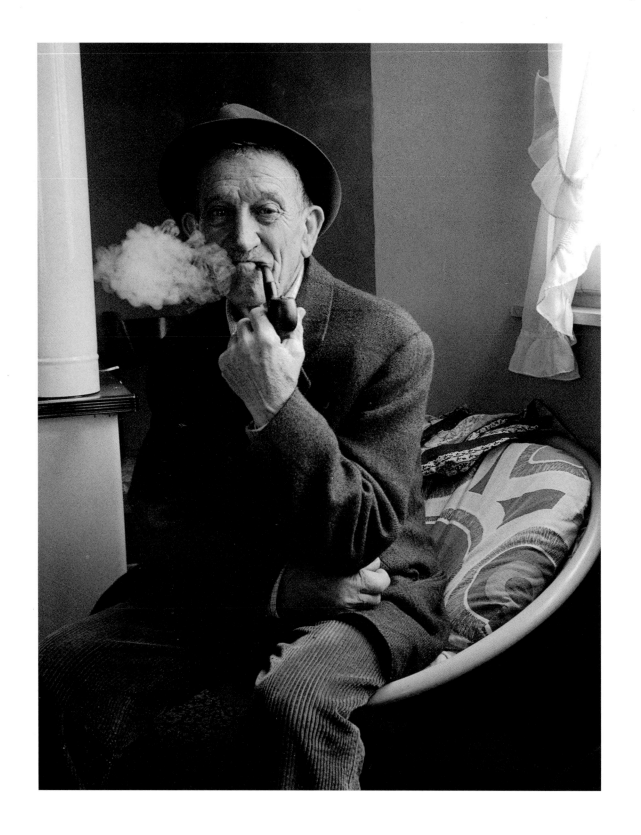

Signor Ugolotti, Apennine
farmer who hid me behind
enemy lines during the war

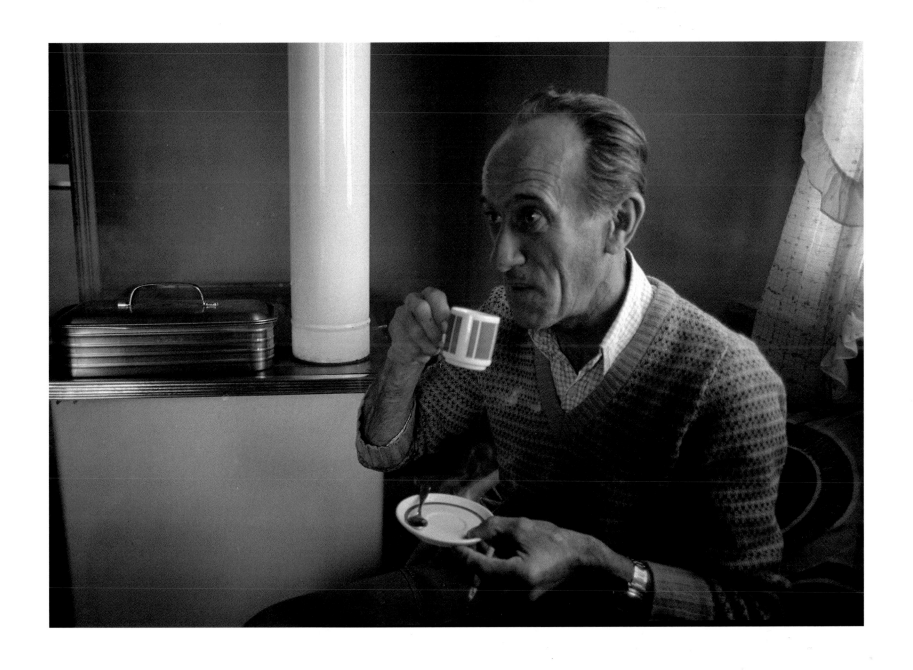

Signor Ugolotti's son

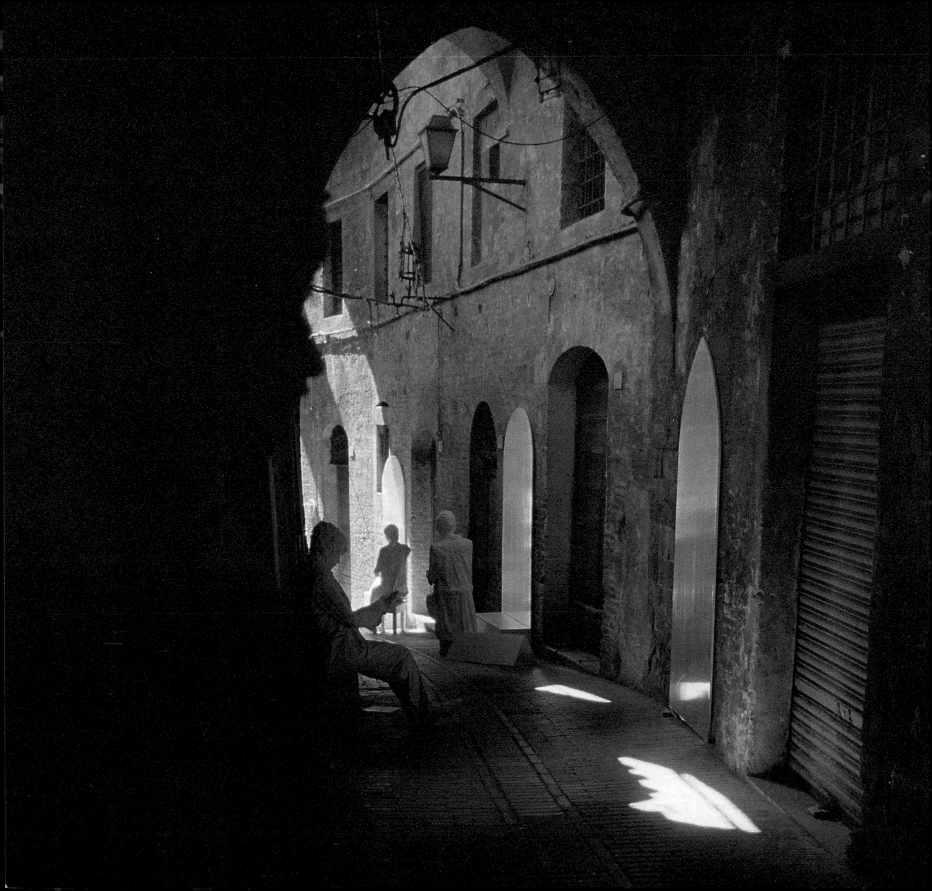

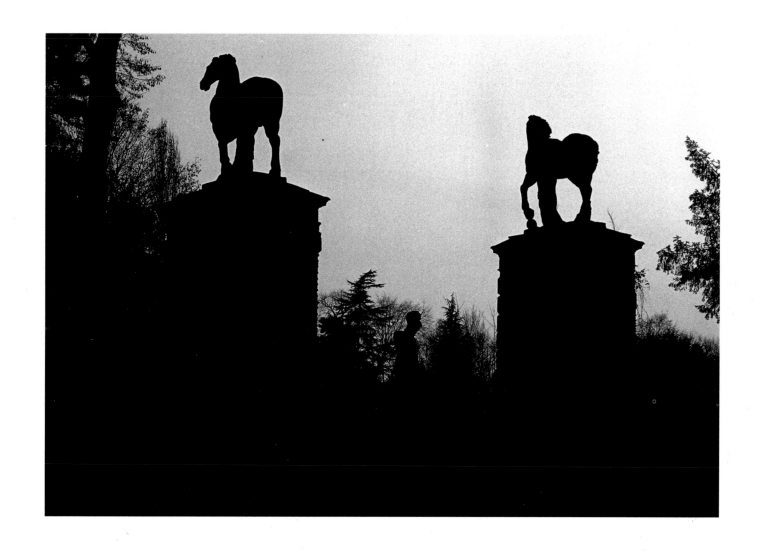

OPPOSITE Village street in
Apuan Alps, Italy

Horse statues in the Galoppatoio the
riding track in the grounds of Villa
Bolasco near Treviso, northern Italy.

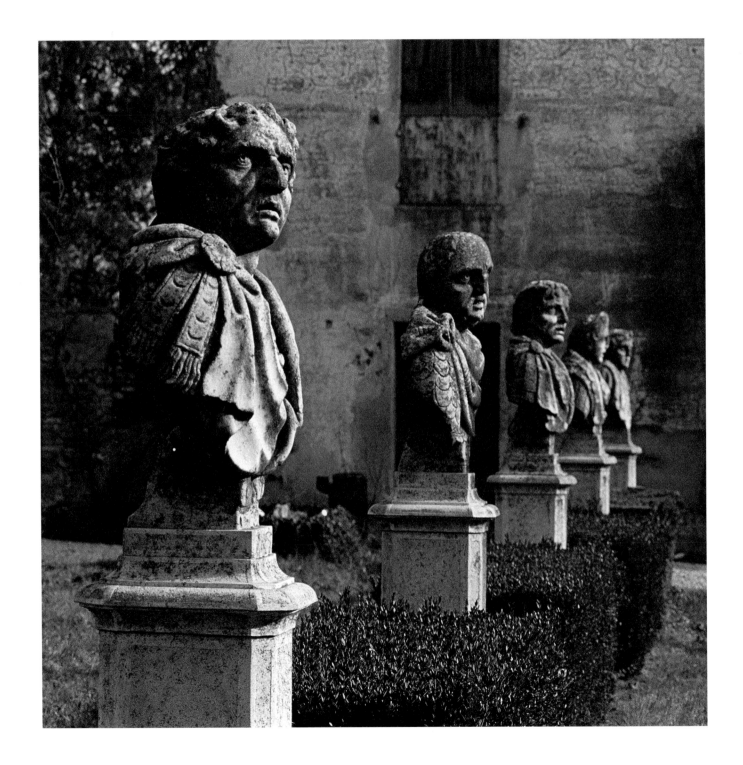

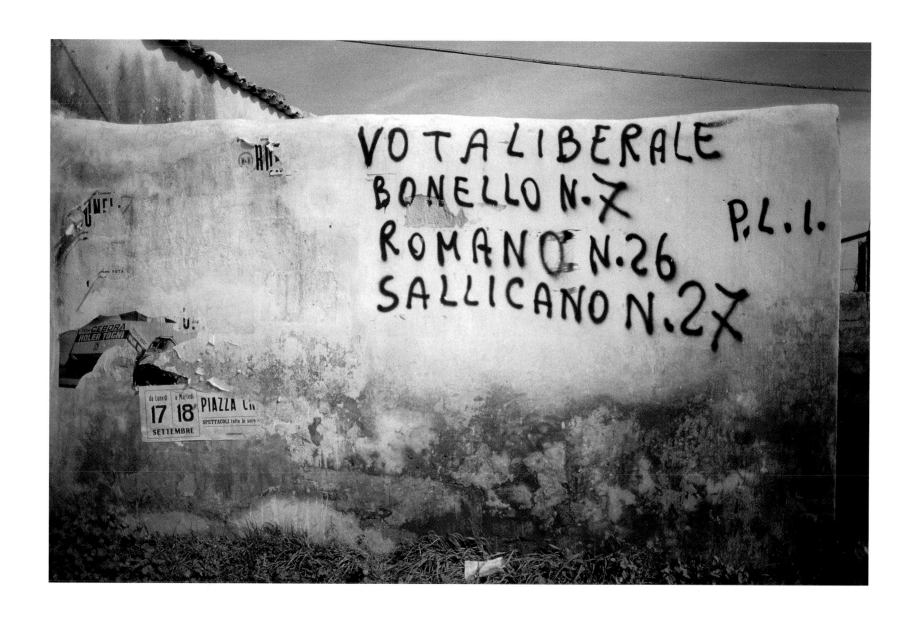

OPPOSITE Strange busts outside an Italian villa,
looking a little put out by the political graffiti above.

OVERLEAF Vines on the march, Veneto.

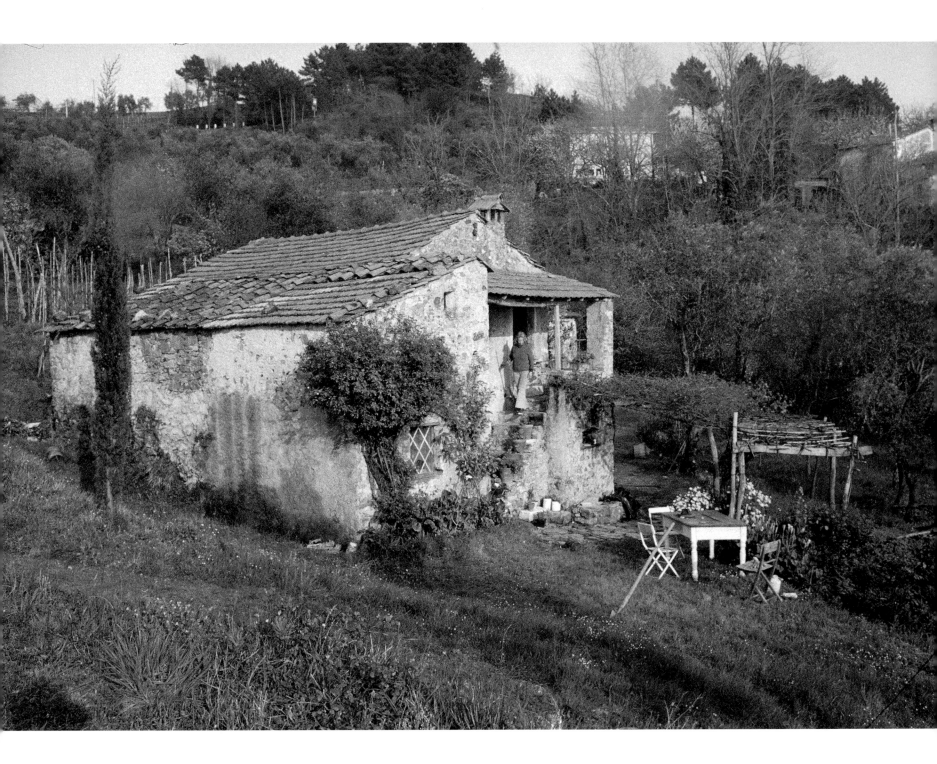

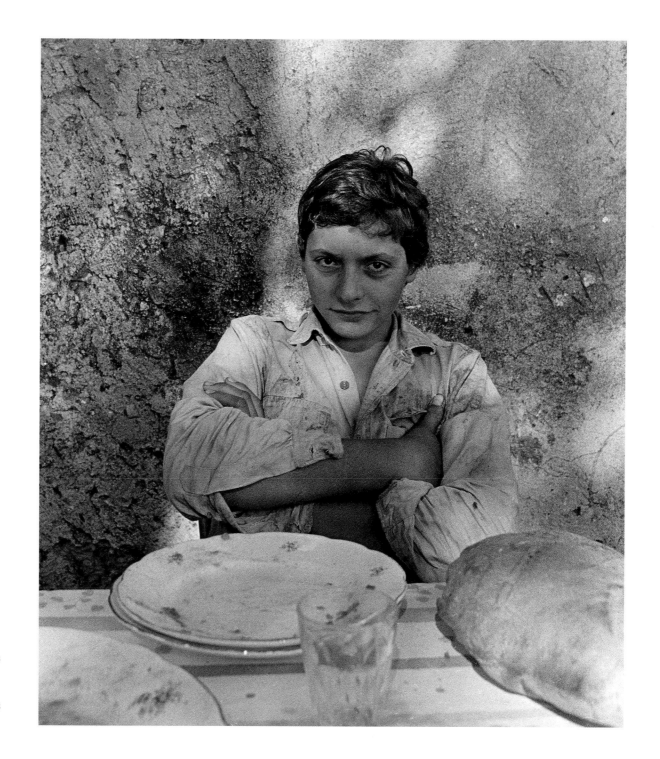

OPPOSITE *I Castagni*, otherwise The Chestnuts. The farmhouse near Sarzana in Tuscany that we lived in for many years and will never forget.

RIGHT The son of one of our neighbours at *I Castagni*.

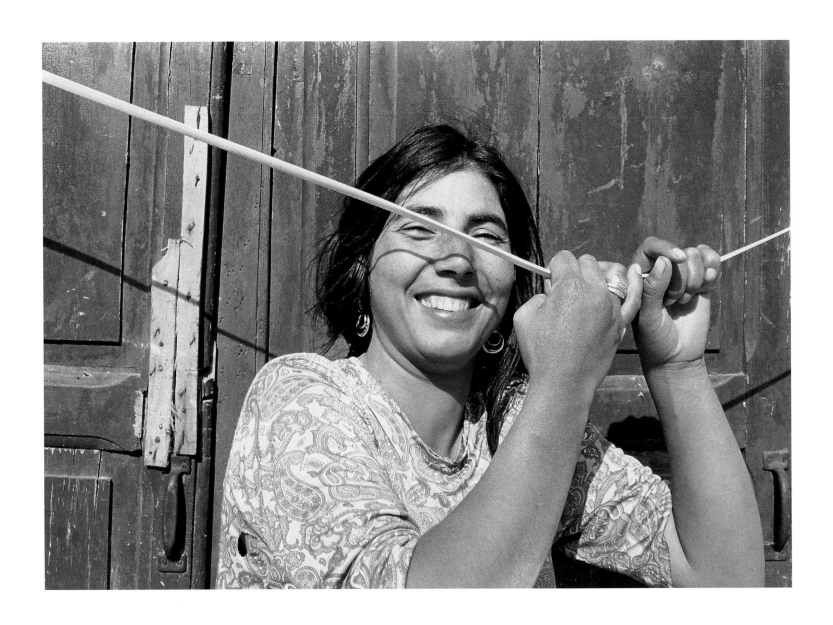

On a washing line in Sicily

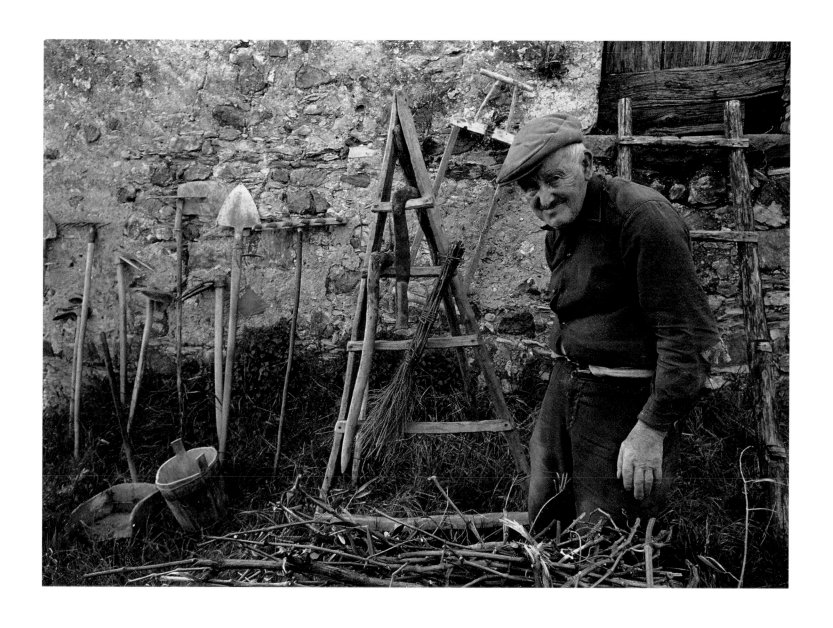

Attilio, described by the local people as
'un ometto molto bravo e intelligente,' here seen
repairing ladders before the grape harvest.

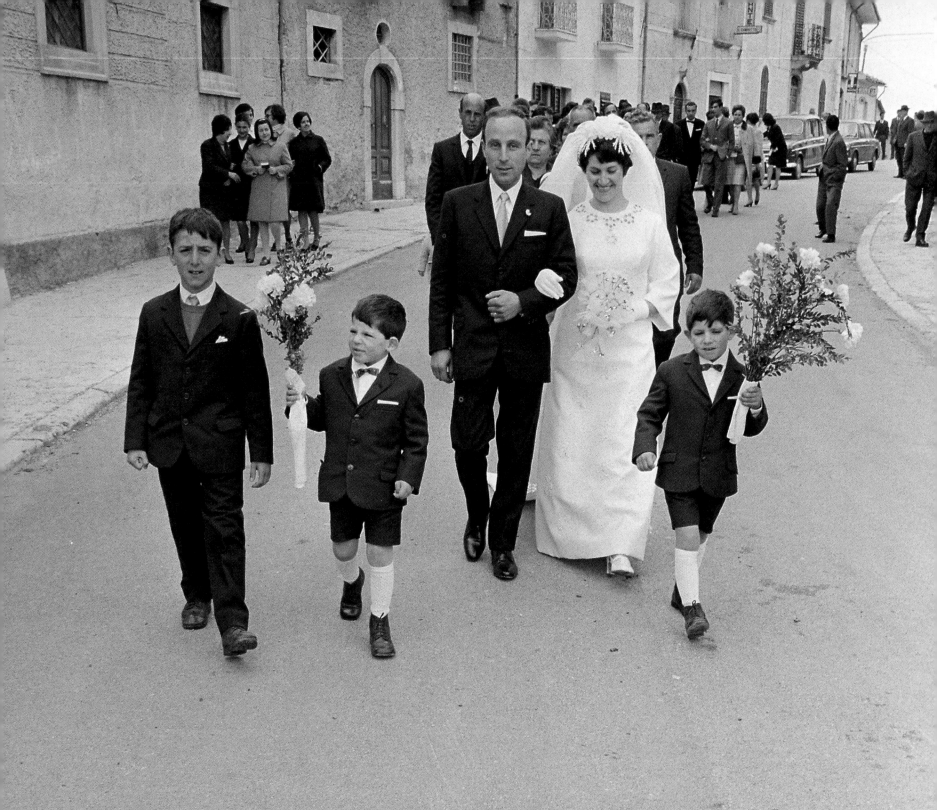

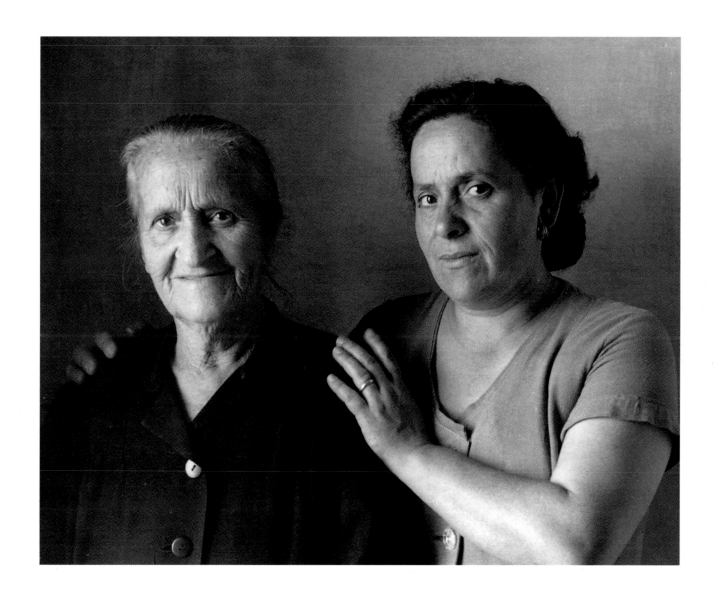

Wedding procession, Molise, Italy

Mother and daughter at Tellaro. The elderly
lady on the left acted as housekeeper to
D. H. Lawrence when he was living in Tellaro,
near Spezia during the First World War.

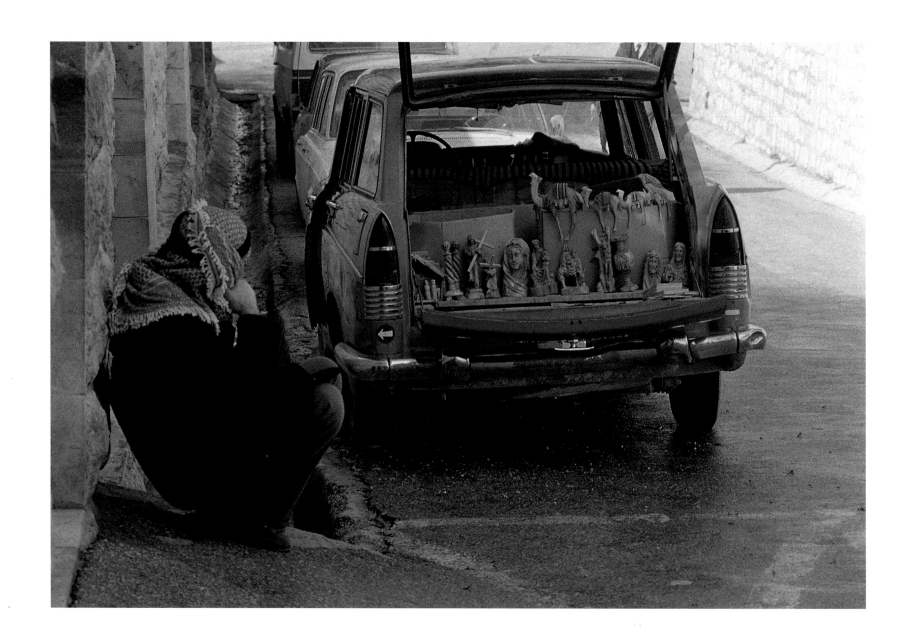

Souvenir seller, Jerusalem

84

Jerusalem

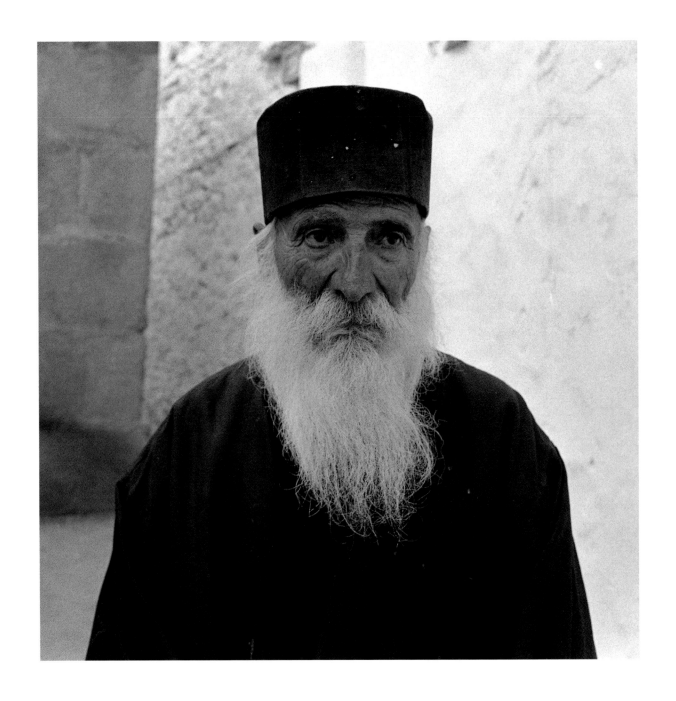

Greek Orthodox monk

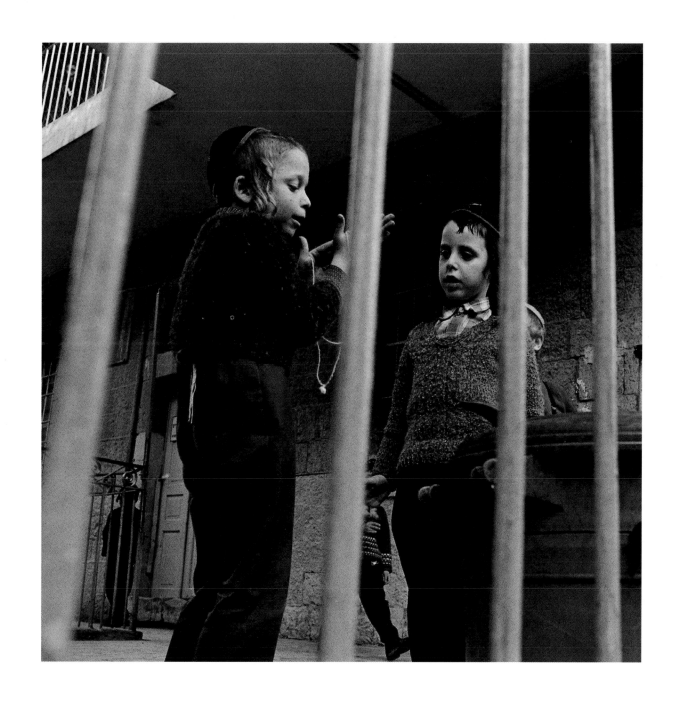

Jewish children playing

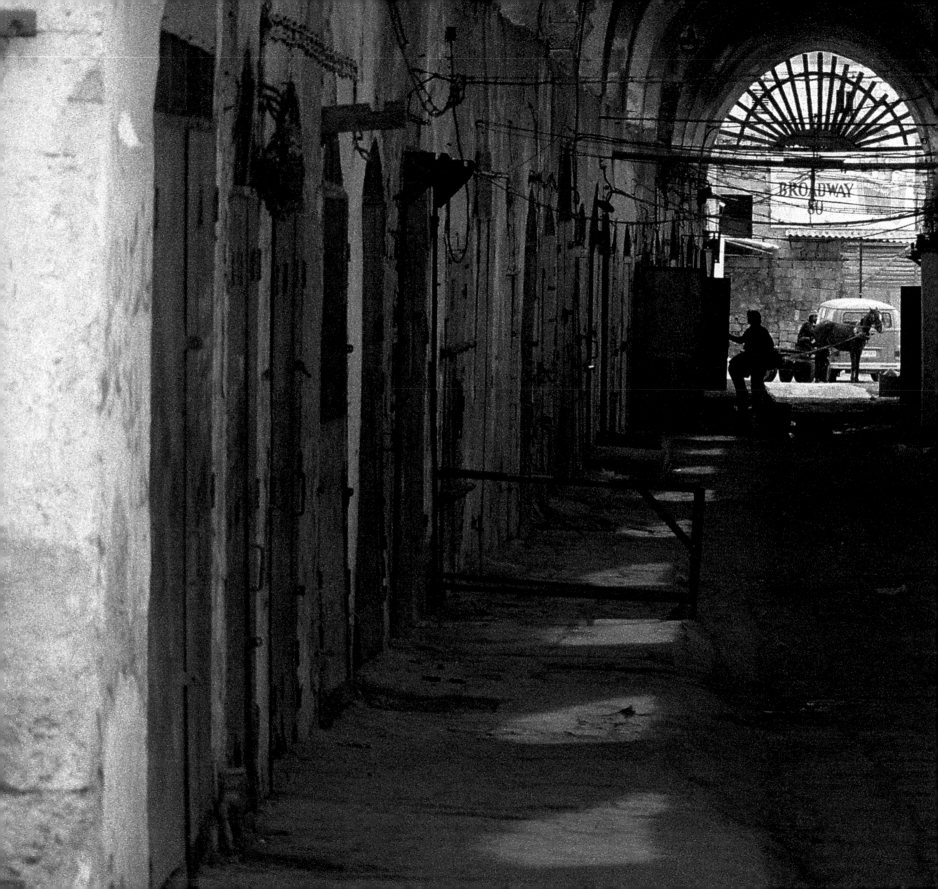

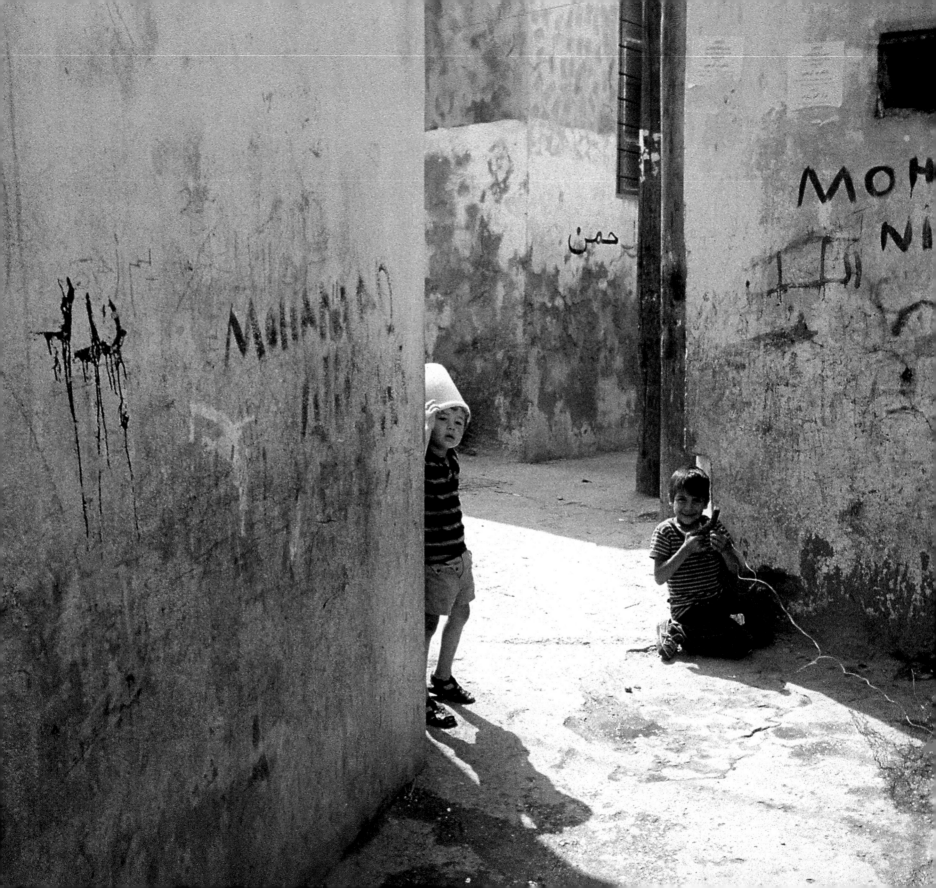

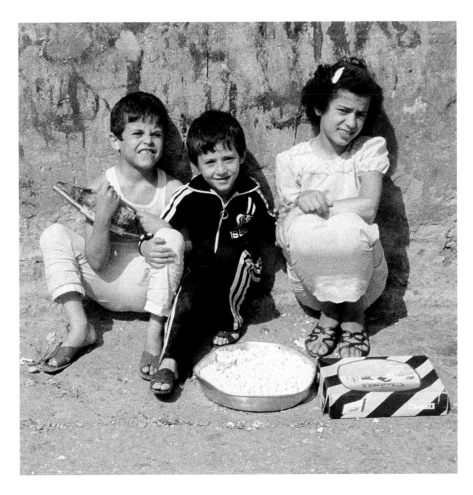

Palestinian children

LEFT Palestinian quarter of Jerusalem

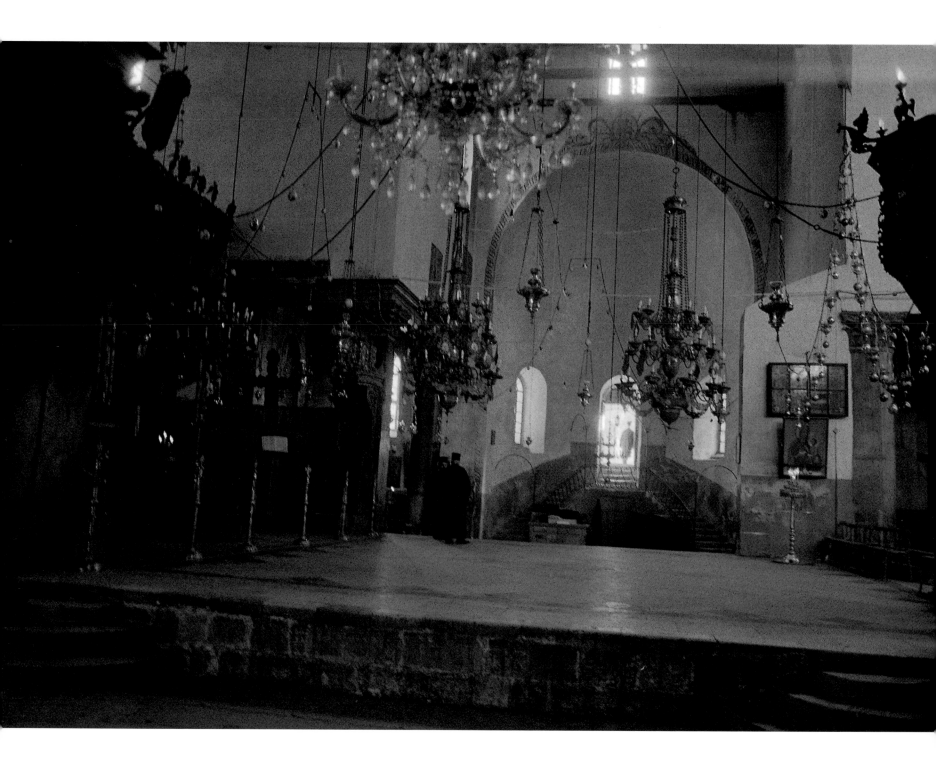

Interior of St Katharine's Monastery, Sinai

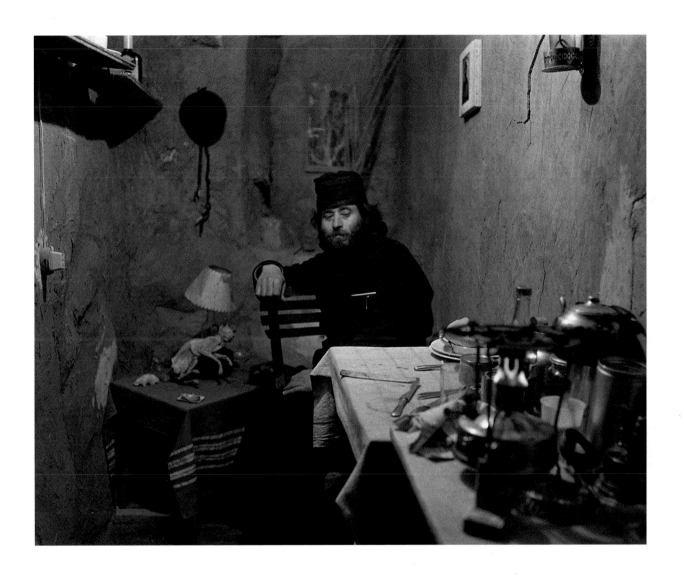

GREEK ORTHODOX MONK,
ST KATHARINE'S MONASTERY

We went down from the top of Mount Sinai by the old penitential route, which was designed to be ascended rather than descended if one was to appreciate properly its penitential significance. It consisted of thousands of stone steps, variously estimated as being fourteen thousand by an Italian pilgrim called Gucci in 1384; six thousand six hundred and sixty-six by an Arab, Al-Makrizi, who lived from 1364 to 1442, quoting another Arab; three thousand five hundred, source unknown; and five thousand by Richard Pococke, the English Orientalist and traveller, who visited the monastery in 1726. However many there were, and we soon gave up counting them, it must have been an appalling job putting them in position.

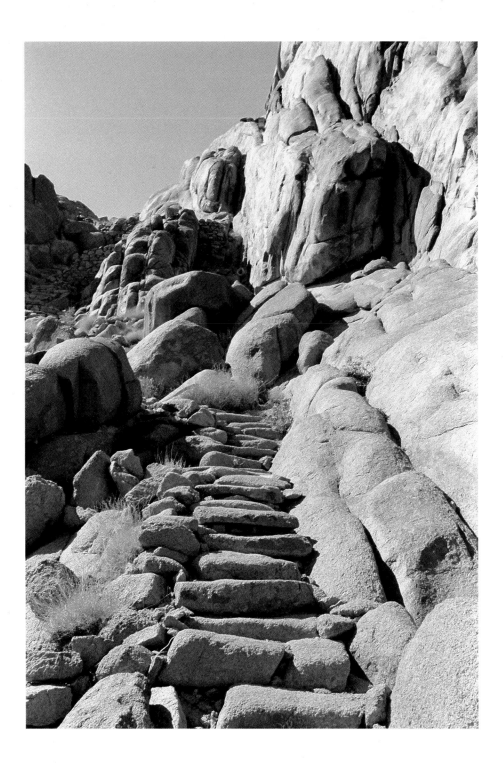

Steps to the summit of the Holy Mountain,
Mount Sinai

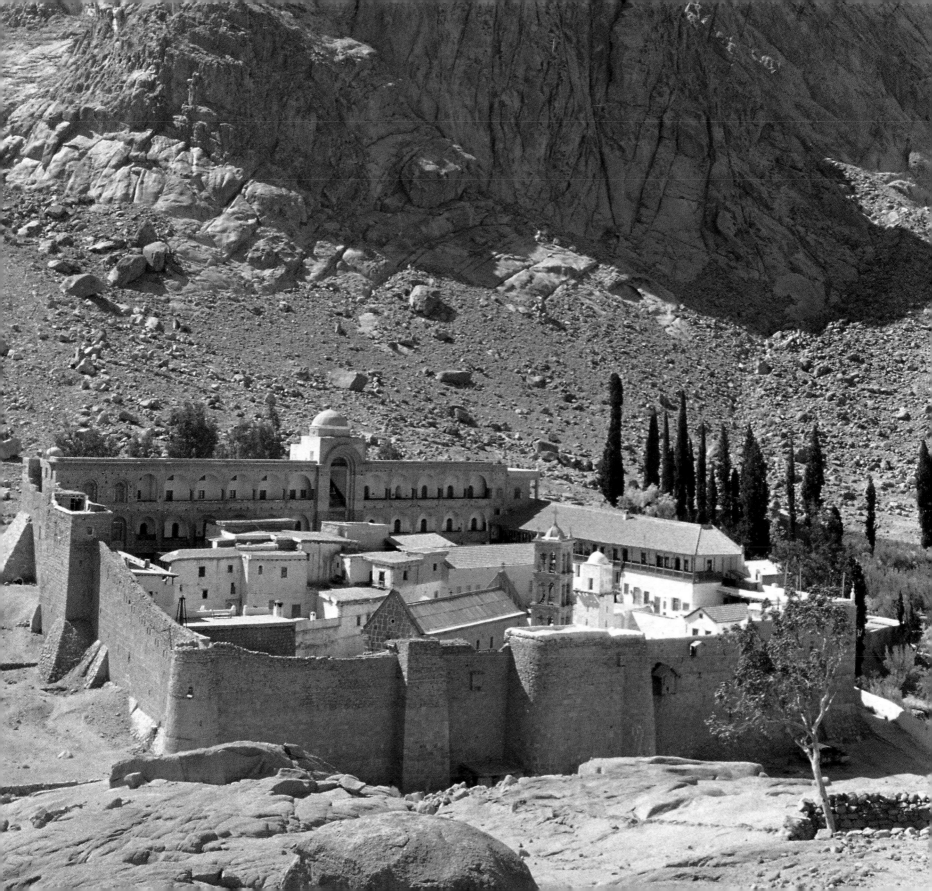

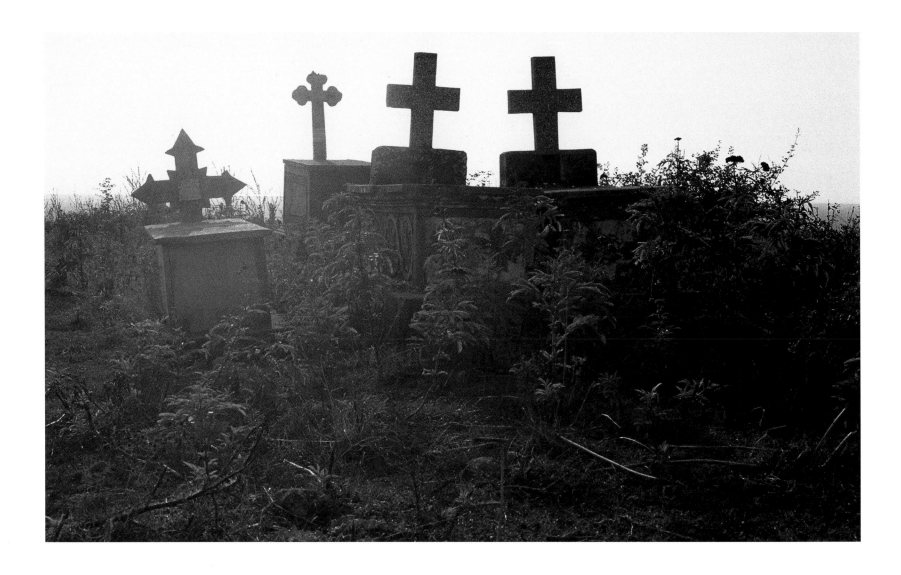

CHRISTIAN GRAVES, ALBANIA

Behind the monastery and the church, which had a number of very beautiful but very badly neglected icons propped up in the narthex, was something now extremely rare in Albania – a partly undesecrated Christian cemetery.

In this one there still remained the tombs of eight members of the same family, the last of whom had been buried as late as 1980.

What influence, I wondered, could this family have had, sufficient to enable their tombs to remain unscathed and to allow for the burial of one of its members to take place so recently? The view from the cemetery was extensive, across fields to the sea and further inland to some low hills with perhaps the most heavily fortified defence system we had seen anywhere in Albania, the piéce de résistance of which was a battery of twenty-four guns.

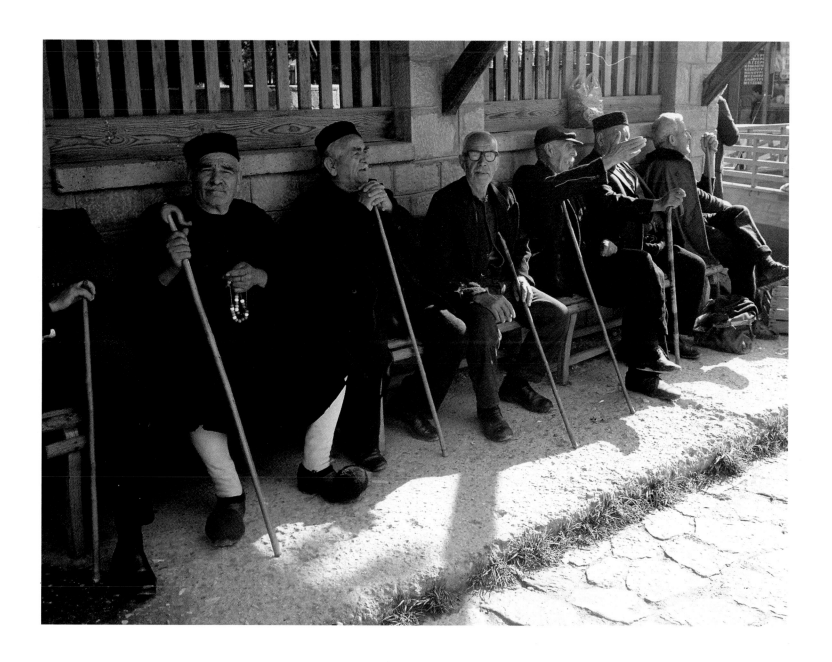

Mountain men

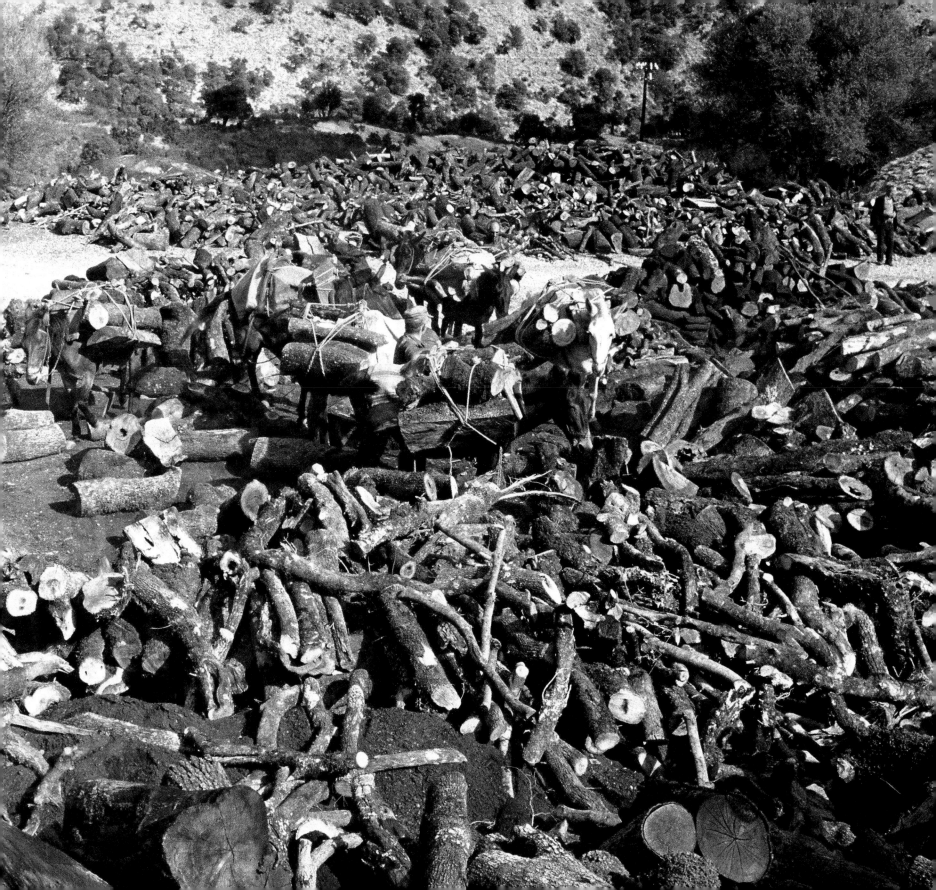

CHARCOAL BURNER, ALBANIAN/GREEK BORDER

When we visited Suli its isolation was about to be destroyed by a road which was being bulldozed through this wild mountain region in which there were scarcely any habitations apart from herdsmens' bothies and those built by charcoal burners.

Long lines of mules laden with wood were being brought down from the heights by savage looking mountaineers and their equally wild looking womenfolk. Huge piles of wood lay about, in what appeared to be the utmost confusion. To burn charcoal they set up the timber on end in conical piles up to twelve feet high and anything up to twenty feet in diameter at the base. They then covered them with earth and charcoal dust, leaving a vertical chimney in the middle, open to the air. These piles were now smoking away rather like wigwams with fires burning away inside them.

Wild-looking though they might be, these charcoal burners were kindly, hospitable people. Taking us to their camp fire, plying us with delicious, sweet, slightly smoky tea which had some unidentifiable herb in it.

How long these people would continue to earn their living in these mountains once the road was completed was uncertain. 'The wood' as one of them who spoke Italian said, 'will still have to be cut and brought down to the road. But it seems likely that it will be loaded on lorries and taken to some modern plant where the charcoal will be made using kilns and retorts, which is a less wasteful method.' He spoke with a complete absence of rancour, almost with resignation as I had noticed that simple people often do when they find their way of life threatened, in this case one which their forebears had practised since time immemorial.

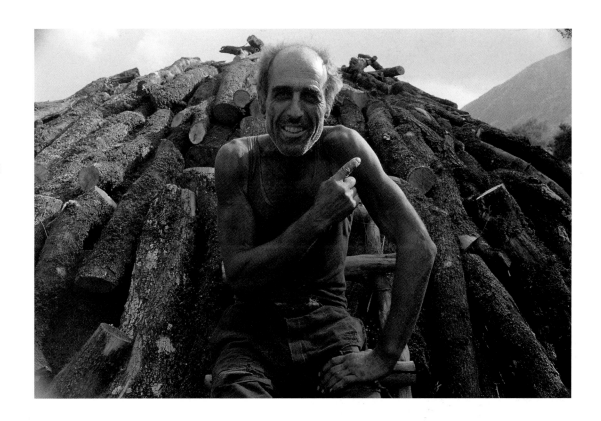

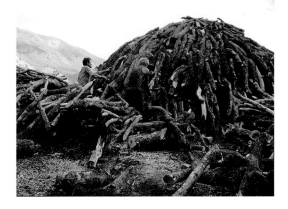

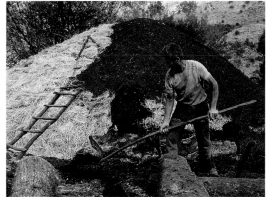

99

OPPOSITE FARMER IN THE
VALLEY OF THE KRMA

In one of these villages, very close to the Austrian
border, all the male inhabitants were killed by
Fascists. And from that day all the females dressed in
black and a sign was erected forbidding entry to all
Italians and Germans. The name of the village was
changed to Strmec – 'village of the Black Women'.

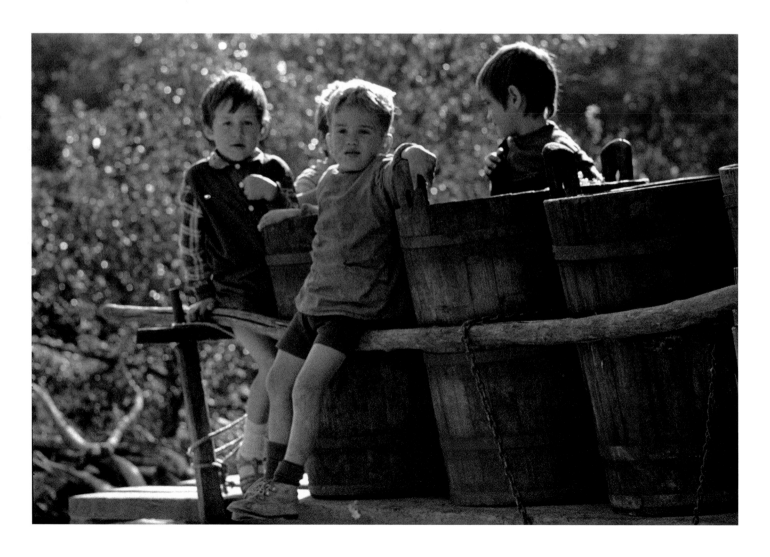

Children riding a tractor to a wine harvest

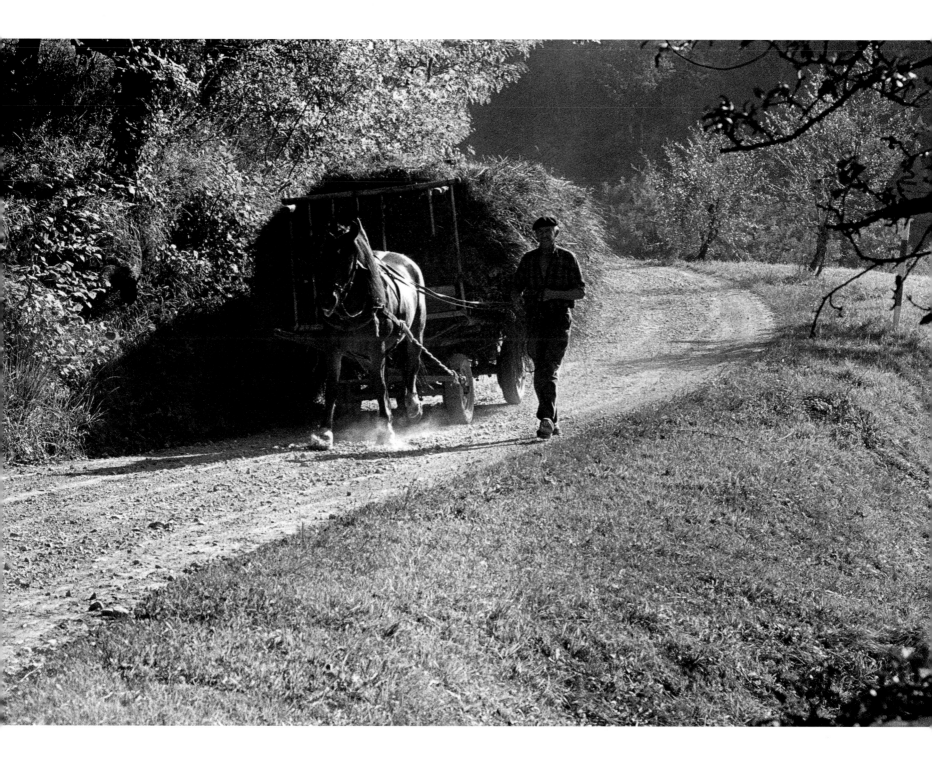

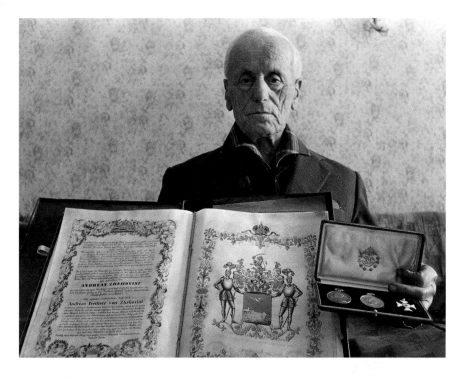

Bogomil Čehovin, a descendant of General Čehovin, displays his ancestor's honours. In front of the Čehovin house which stands on a bank of the Branica in a very prominent position is a tall white statue of Mr Bogomil Čehovin's great uncle, General Baron Andrea Čehovin. He was born in Brancia in 1810 and died at Baden near Vienna in 1855, after a most distinguished military career. He played an important part in the battles of Livorno, Somma Campagna, Mortara and Montanara. It was the Emperor Franz Josef of Austria himself who decorated the Baron with the Highly Distinguished Cross and had the statue erected with the inscription: 'To the Bravest of the Brave'.

During the Second World War the statue was damaged by Fascists who smeared it with tar. And to avoid further vandalism the Čehovini had it buried in their kitchen garden leaving (presumably by mistake) one boot sticking out of the ground. It has recently been restored, and the Baron stands once more in his original position, high on a pedestal. He wears a uniform covered by a large cloak, but the hand which originally held his sword is empty.

LEFT Apartments in Ljubljana (the capital of Slovenia)

Village in the arcadian valley of the Radovna, close to the Austrian frontier at the foot of Triglav, Slovenia's highest mountain. The scene of a terrible holocaust in the 1940s when numbers of farmers and their entire families were burned alive.

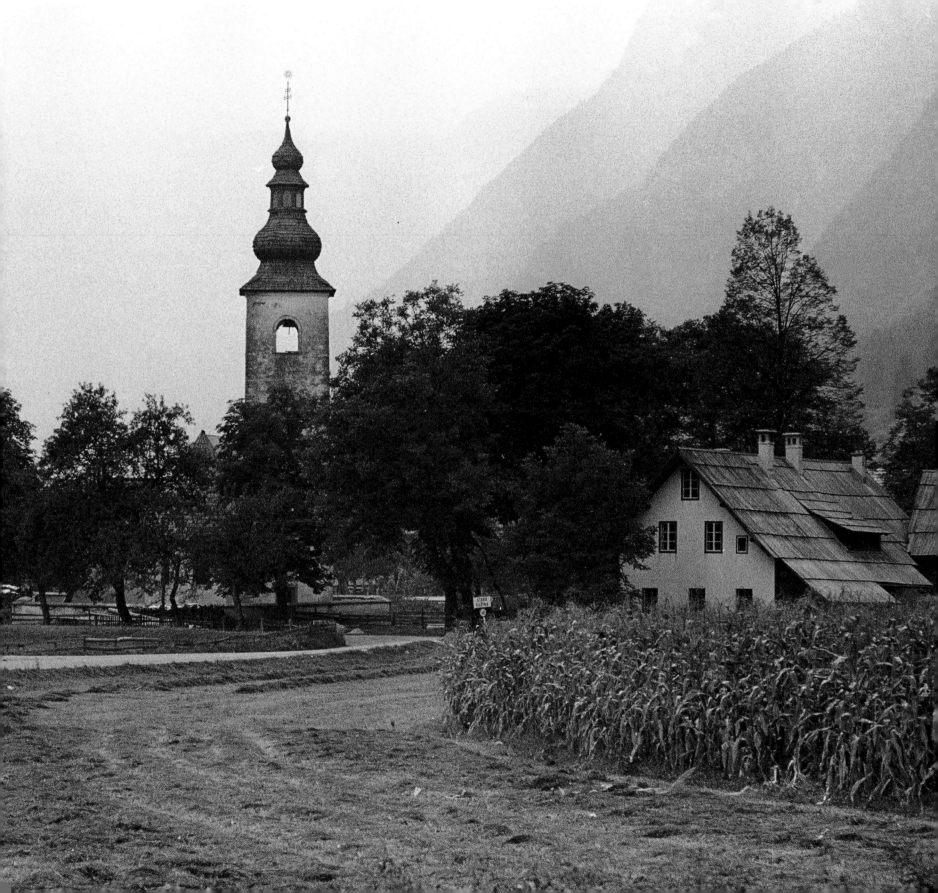

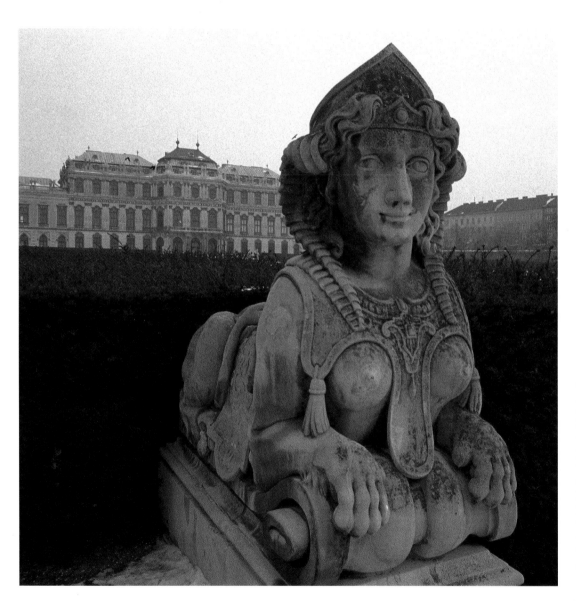

VIENNA

Jolly looking sphinx between the upper and lower
Belvedere, Vienna. Built between 1714 and 1723 by
the architect Johann Lukas von Hildebrandt for Prince
Eugene of Savoy, who continued to occupy another
baroque masterpiece, the Winter Palace, built by
J. B. Fischer von Ehrlacht, which later became the
Finanz-Ministerum, in which he died in 1736. The
Belvedere has what are perhaps the nicest gardens
in the city, and one of the loveliest palaces. The
upper Belvedere now houses a remarkable collection
of modern art, with works by Kokoschka, Munch,
Schiele and Klimt and others.

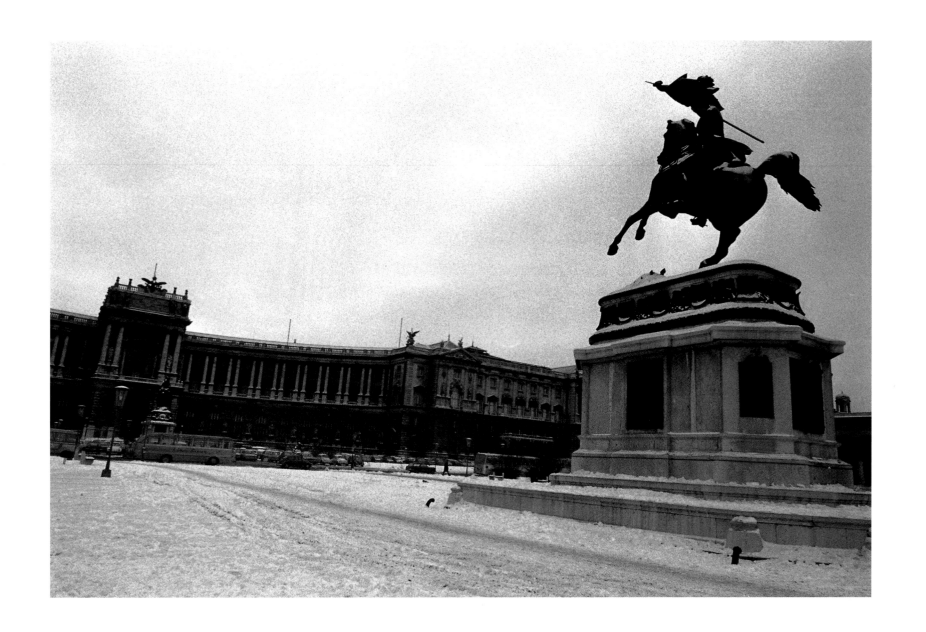

Vienna

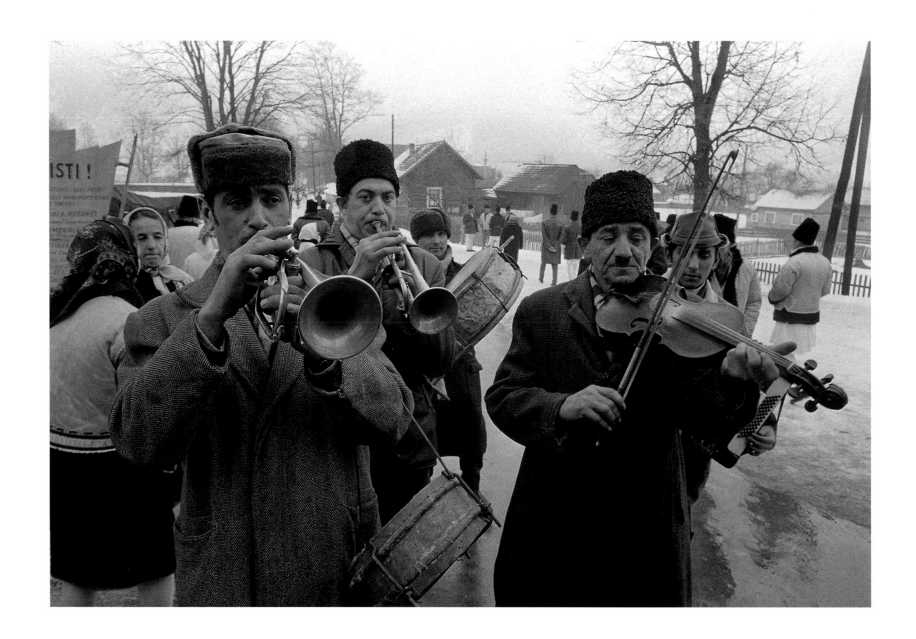

Full blast in Romania

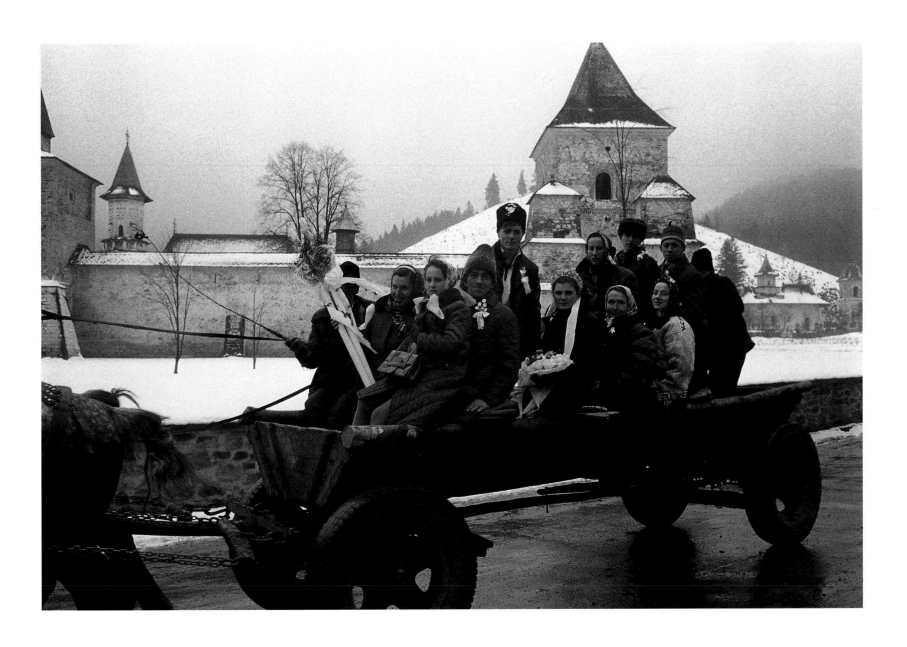

Wedding party in a horse-drawn cart, outside the walled monastery of Sucevita in Moldavia, Romania. Inside, the church was painted with frescoes. Moldavia now has a more sinister reputation as the place where the previous regime set up so-called 'orphanages.'

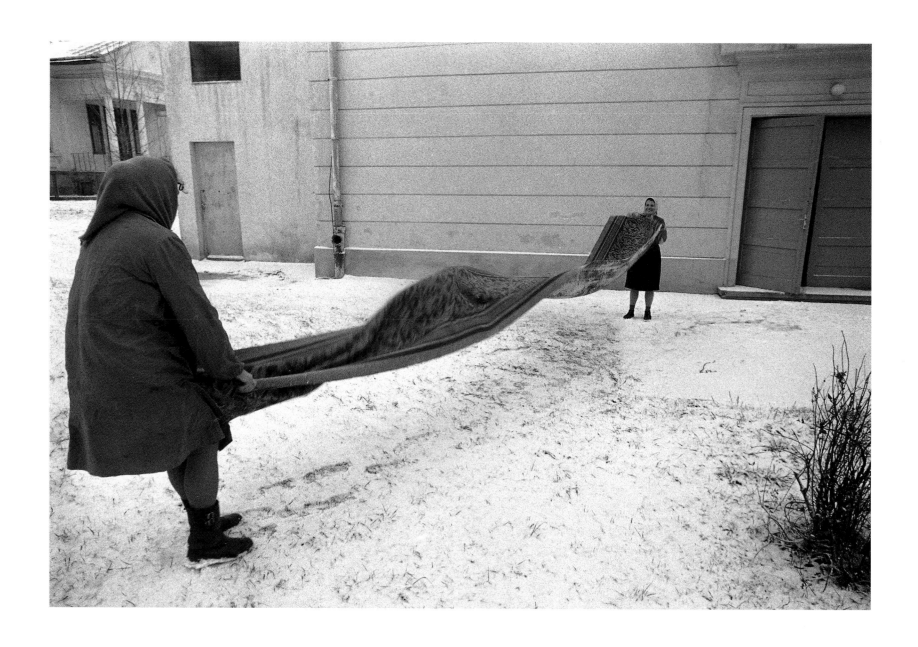

Custodians of an orthodox church shaking out
a carpet, Romania

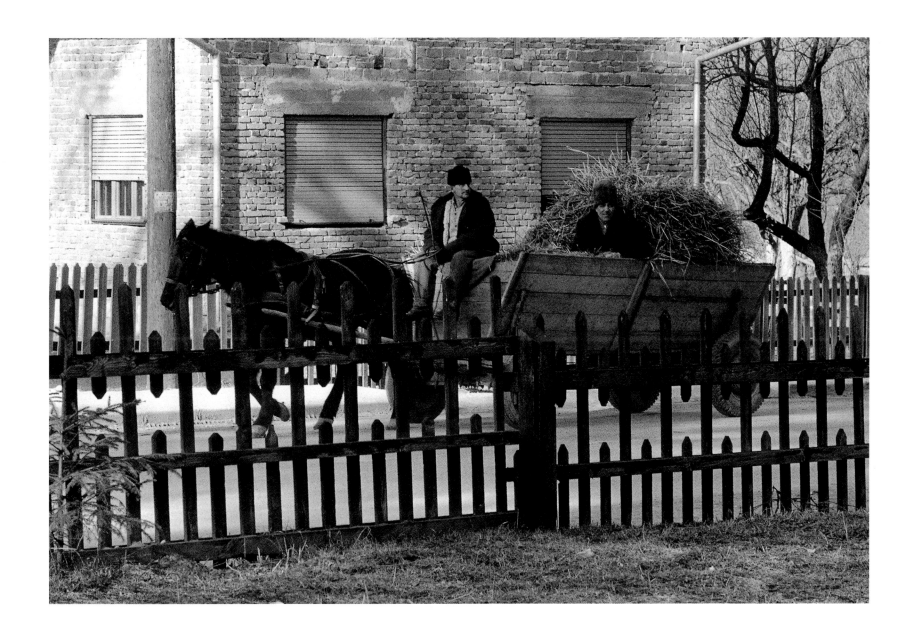

Farmers in Moldavia

Permanent pleating shop, Vienna

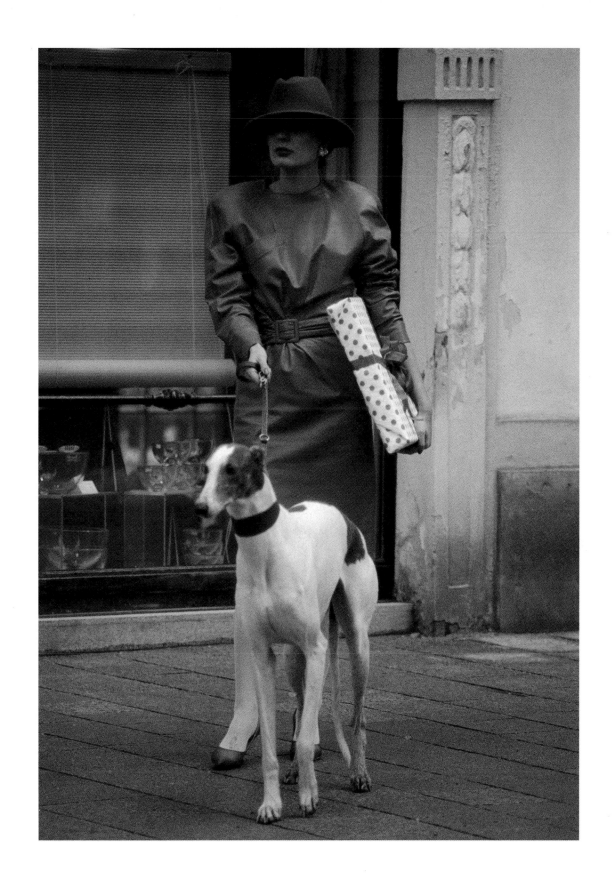

Racy visitor to the Kärtner Strasse. In winter their chaperones will appear in full-length fur coats with hats to match, en route for Demel's patisserie, noted for its torte and an extremely elegant café Konditorei.

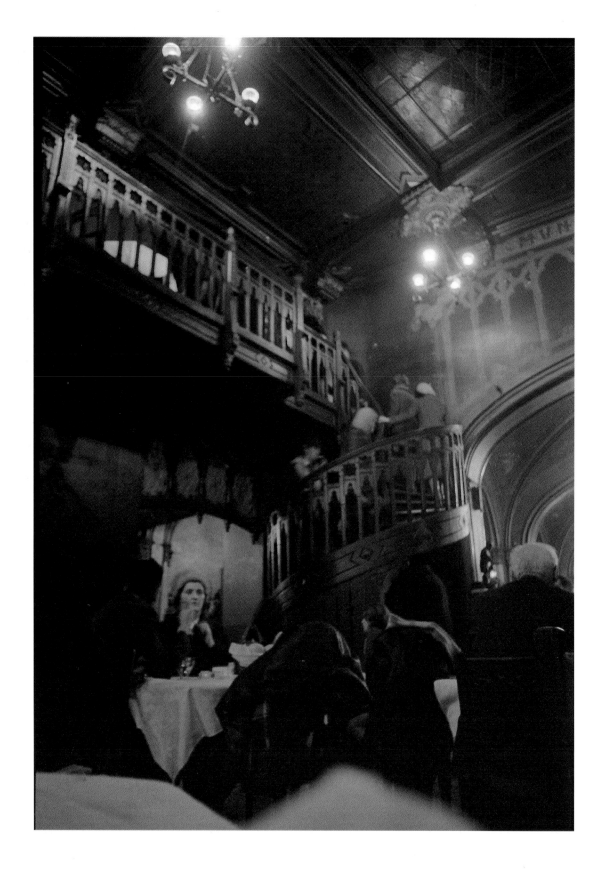

Restaurant, Bucharest

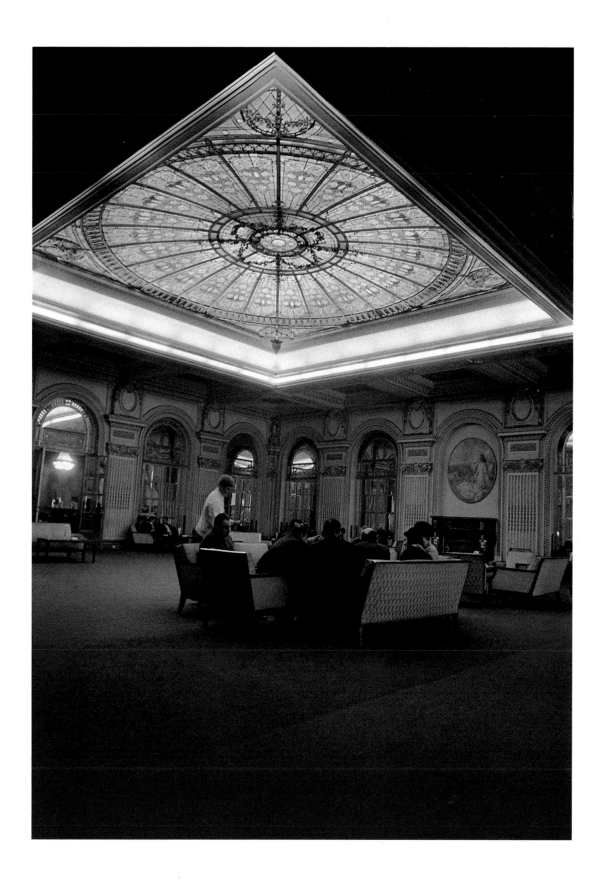

Athénée Palace Hotel, Bucharest

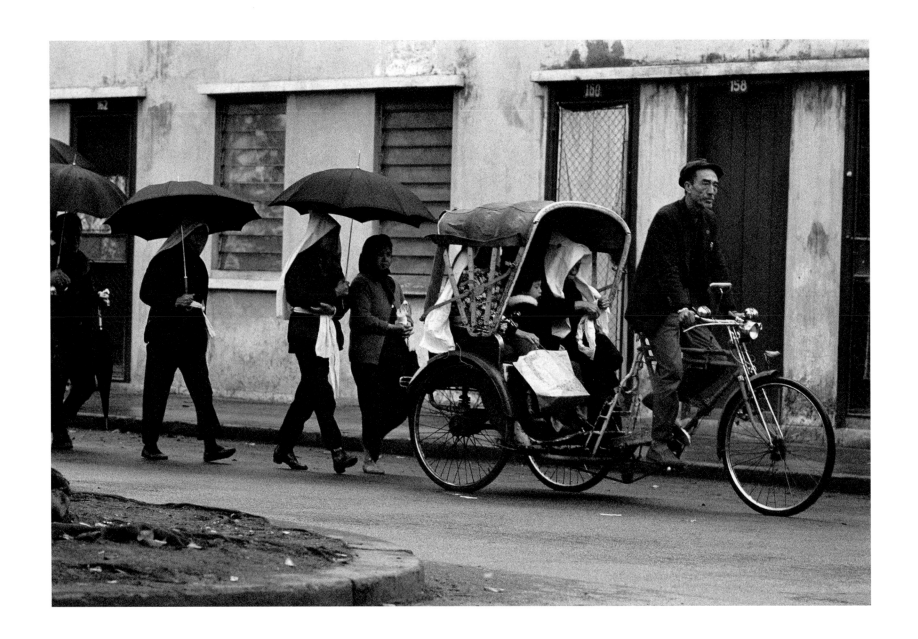

Procession, Macao

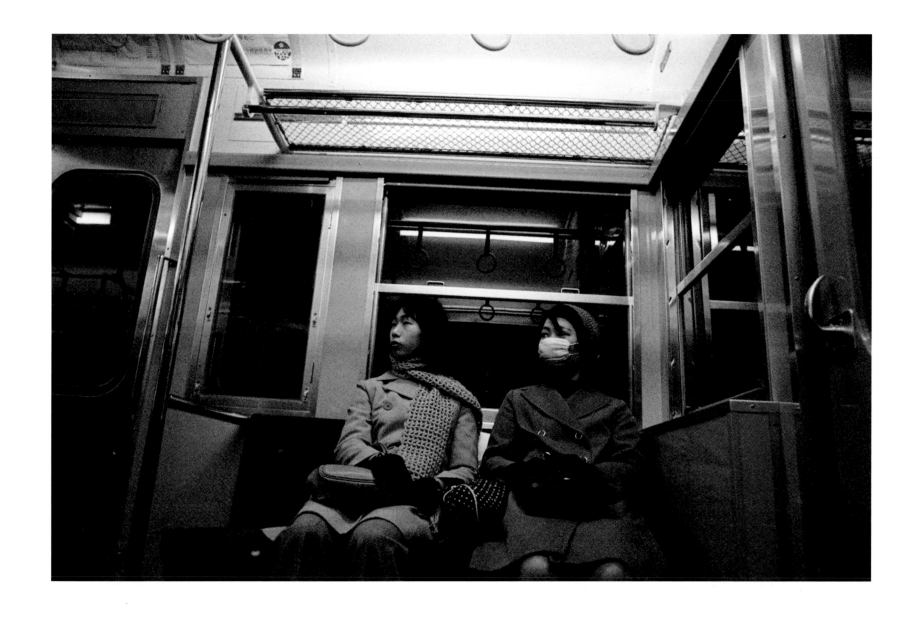

Train in Beijing

OVERLEAF Winter in the moat of the forbidden city

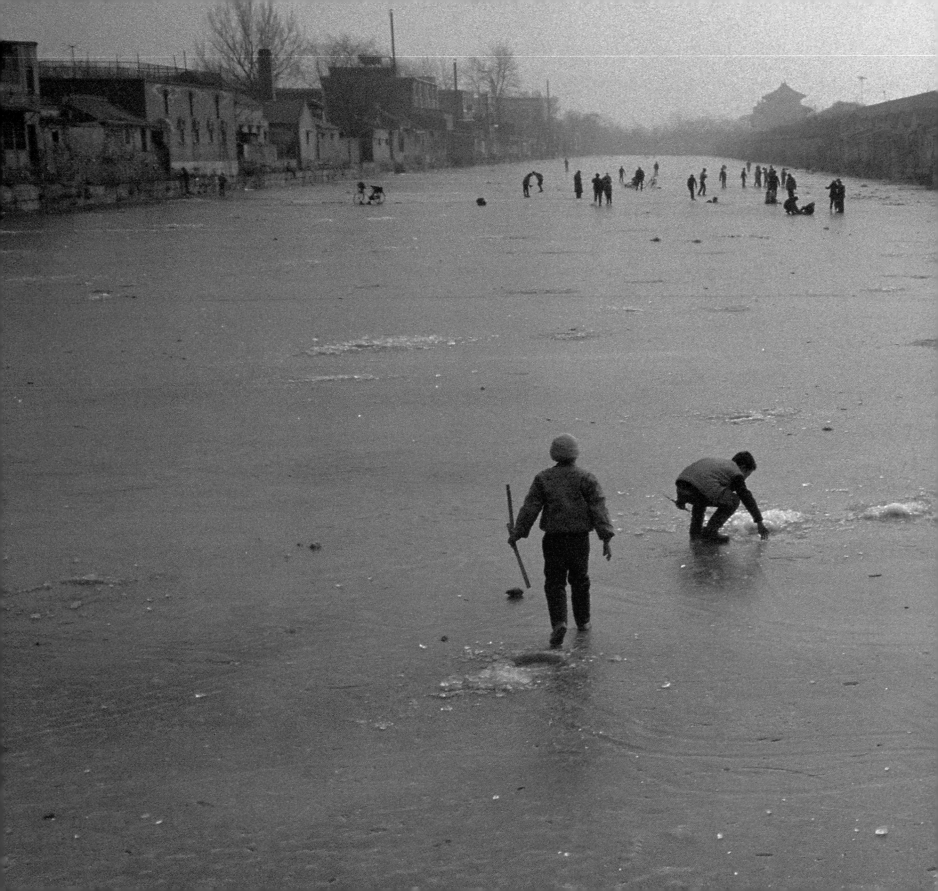

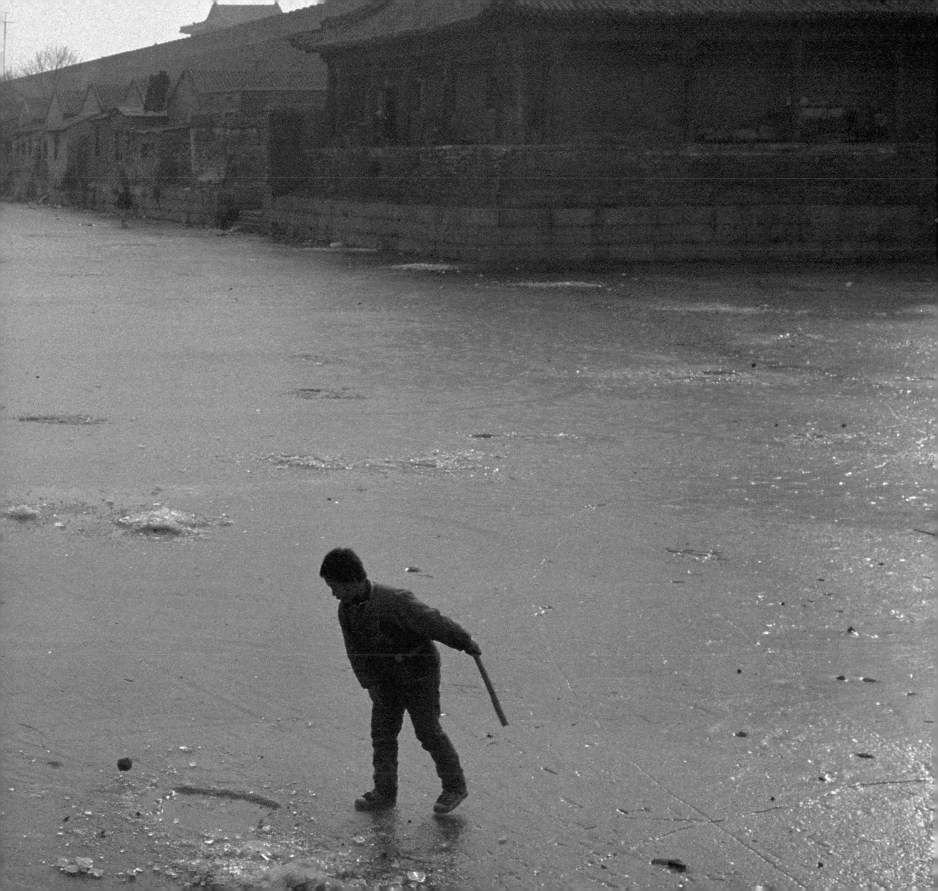

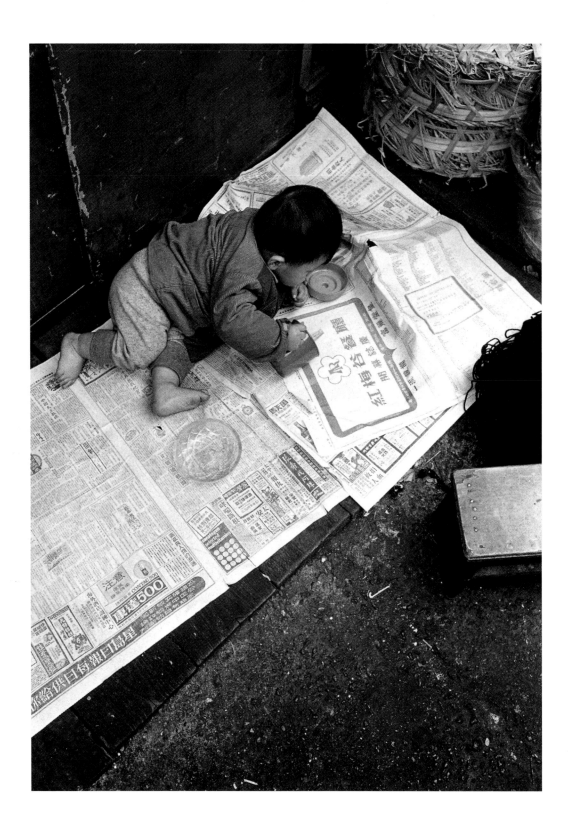

Reading the news, Beijing

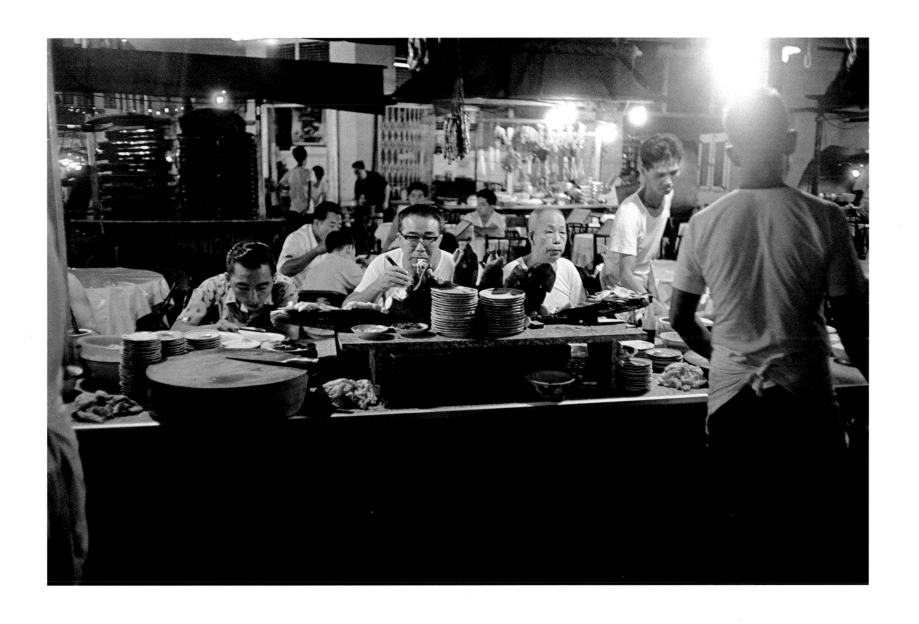

Dim Sum, Hong Kong

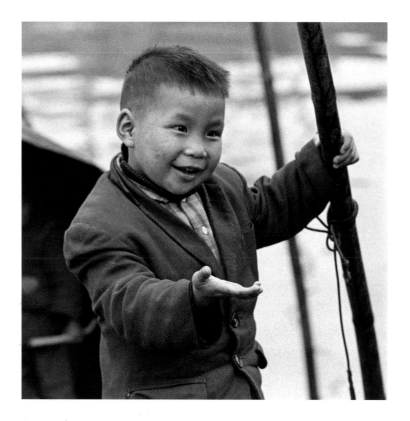

Boy on a boat, Macao

RIGHT Fishmonger, Macao

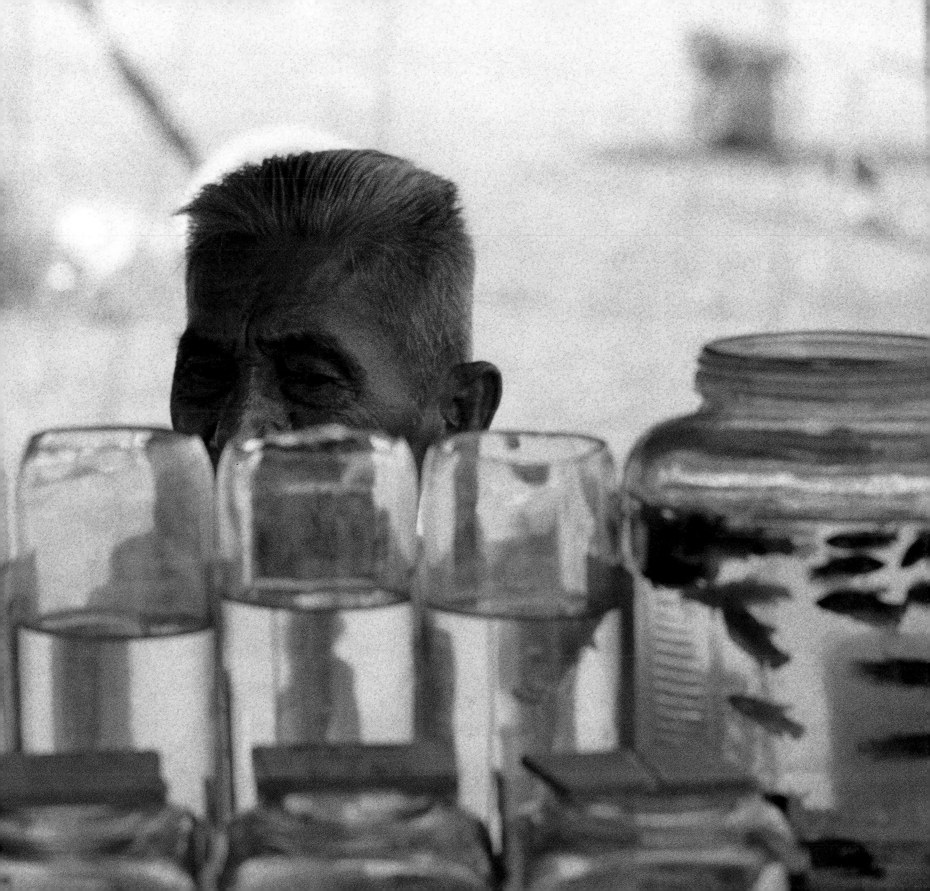

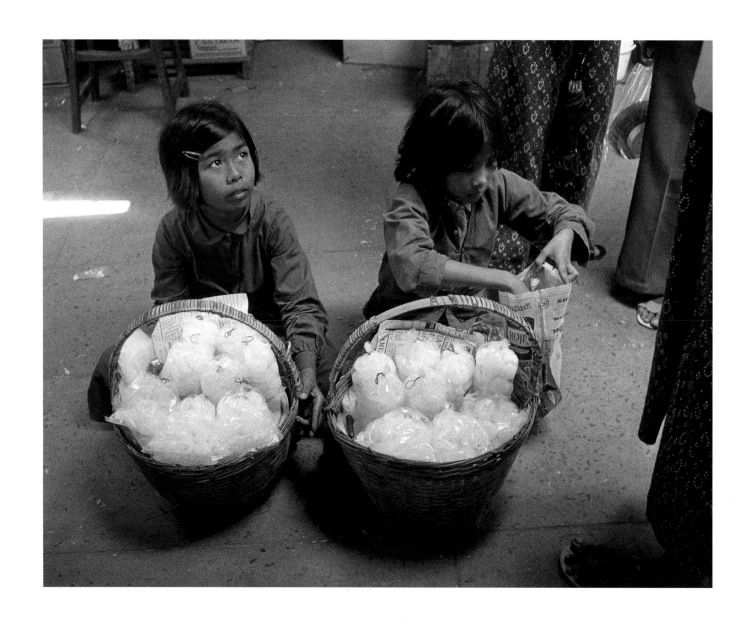

Young street sellers, Macao

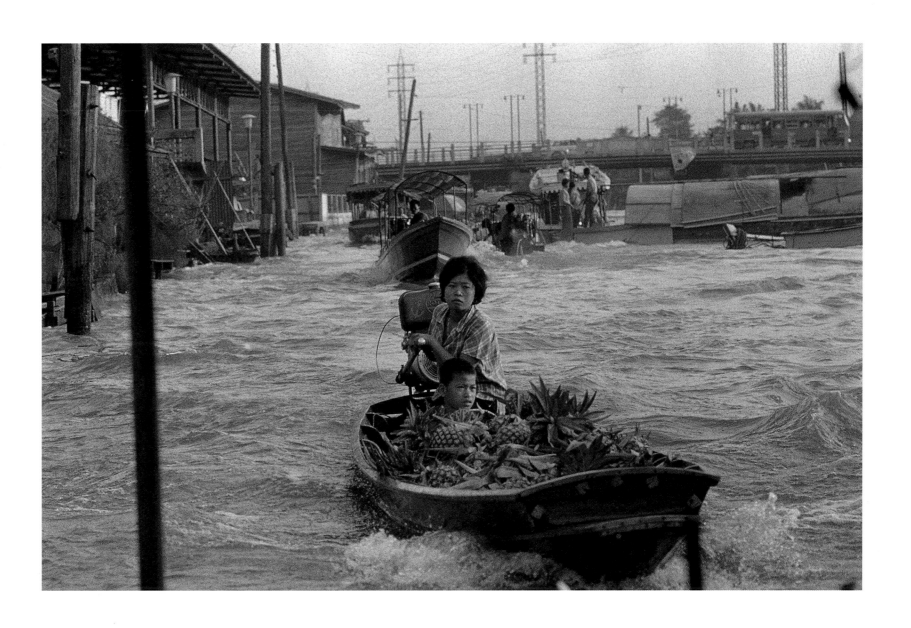

Canals of Bangkok

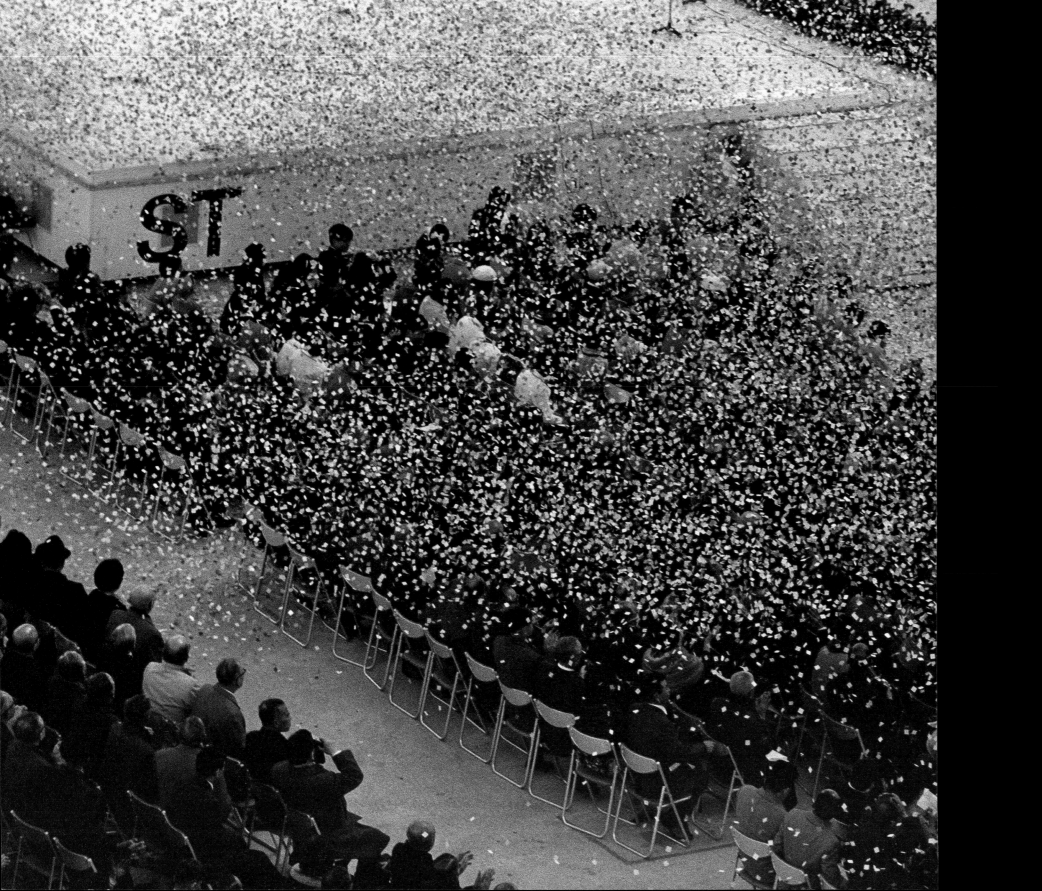

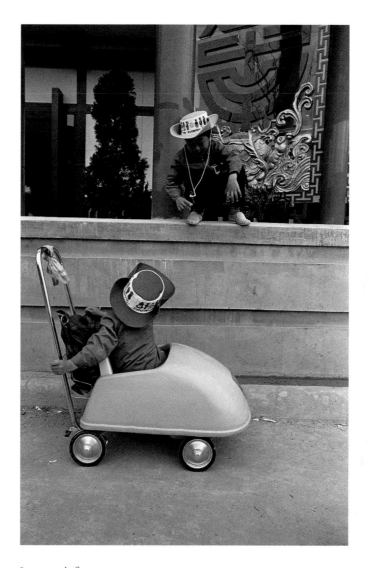

Japanese infant

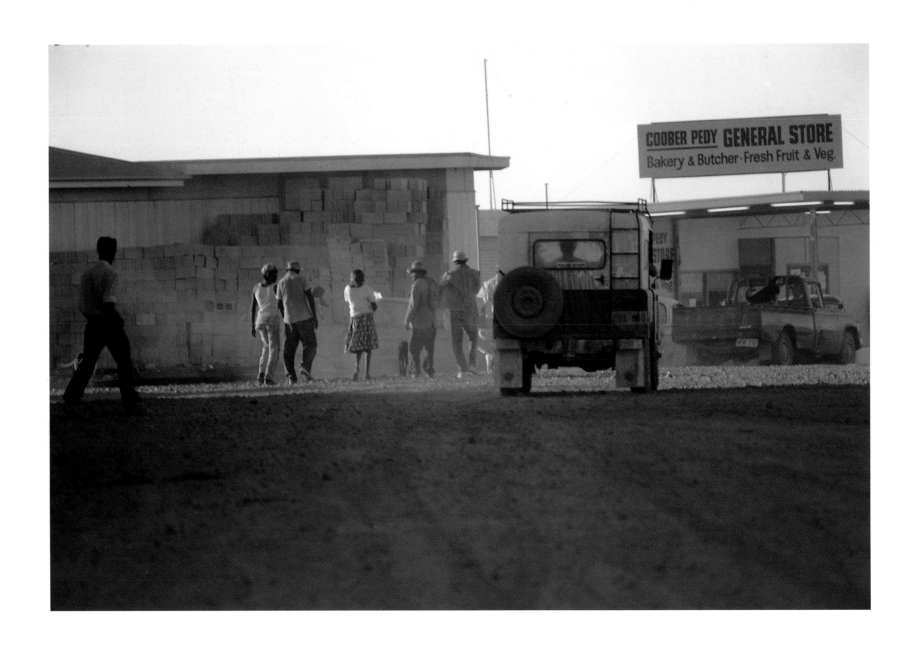

The Opal Mines at Coober Pedy, South Australia

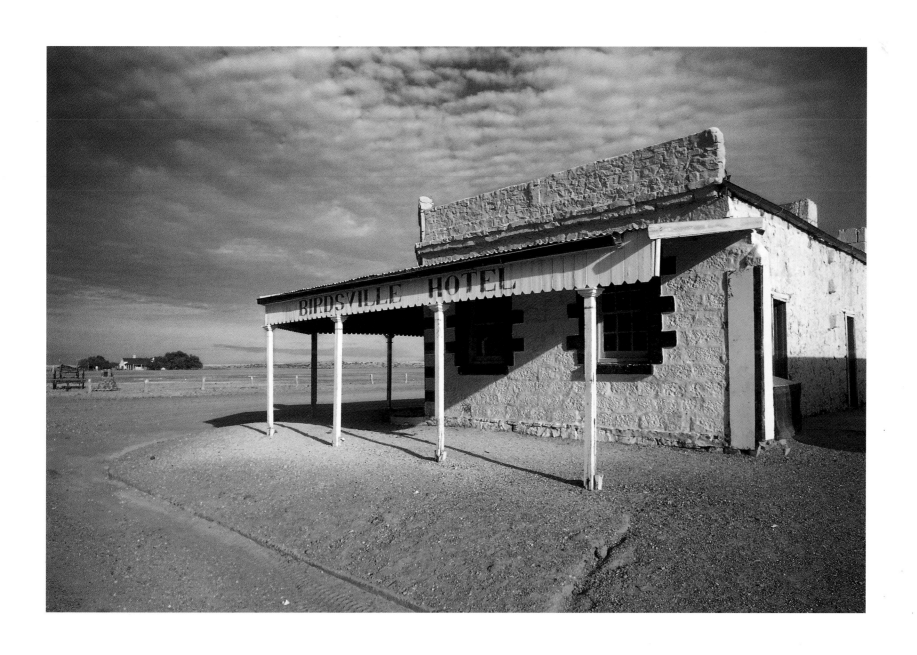

One of the loneliest pubs in Australia, The Birdsville Hotel

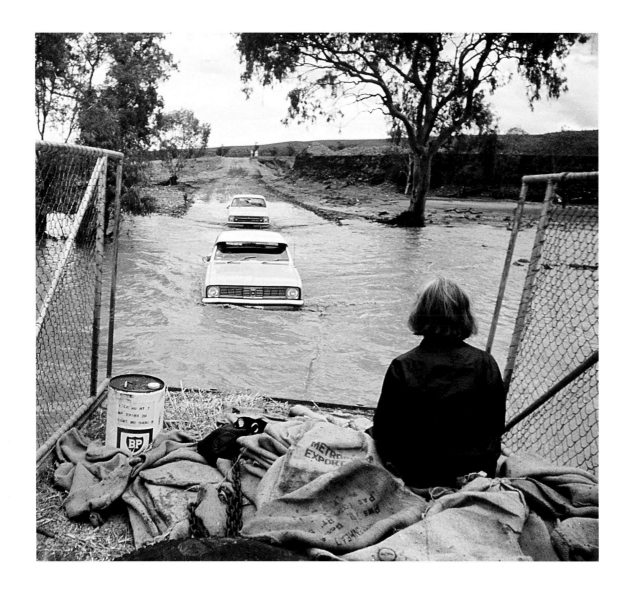

Flash flood in the outback

OPPOSITE Heavy going in the outback

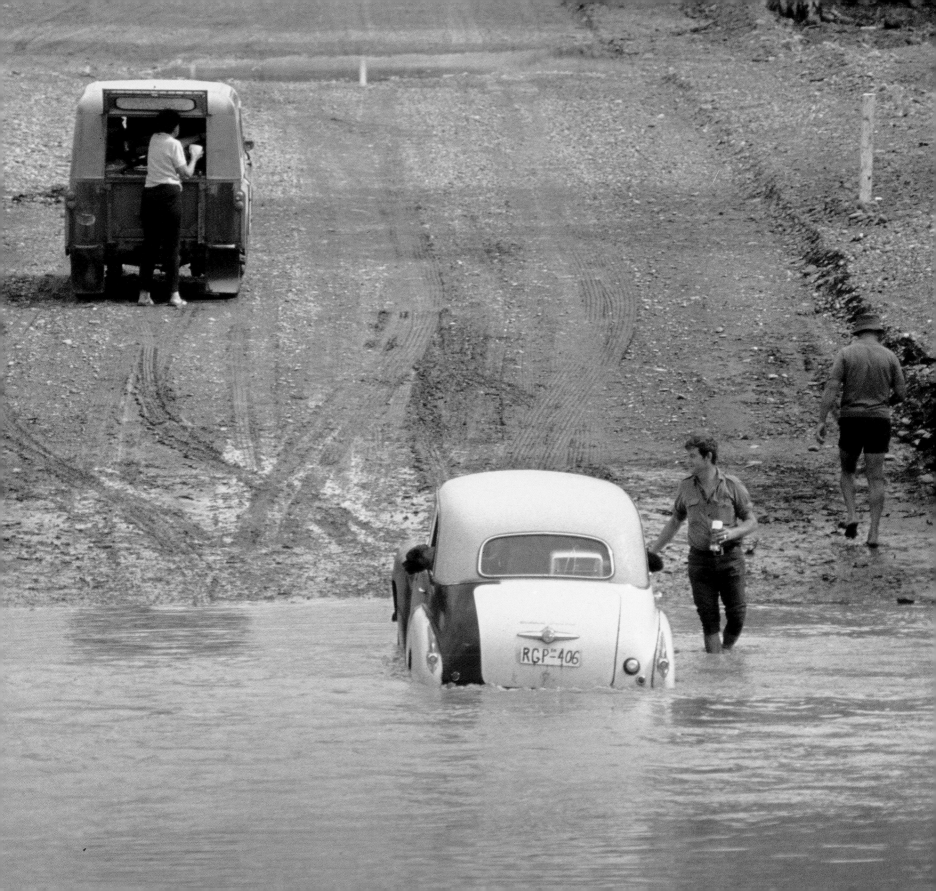

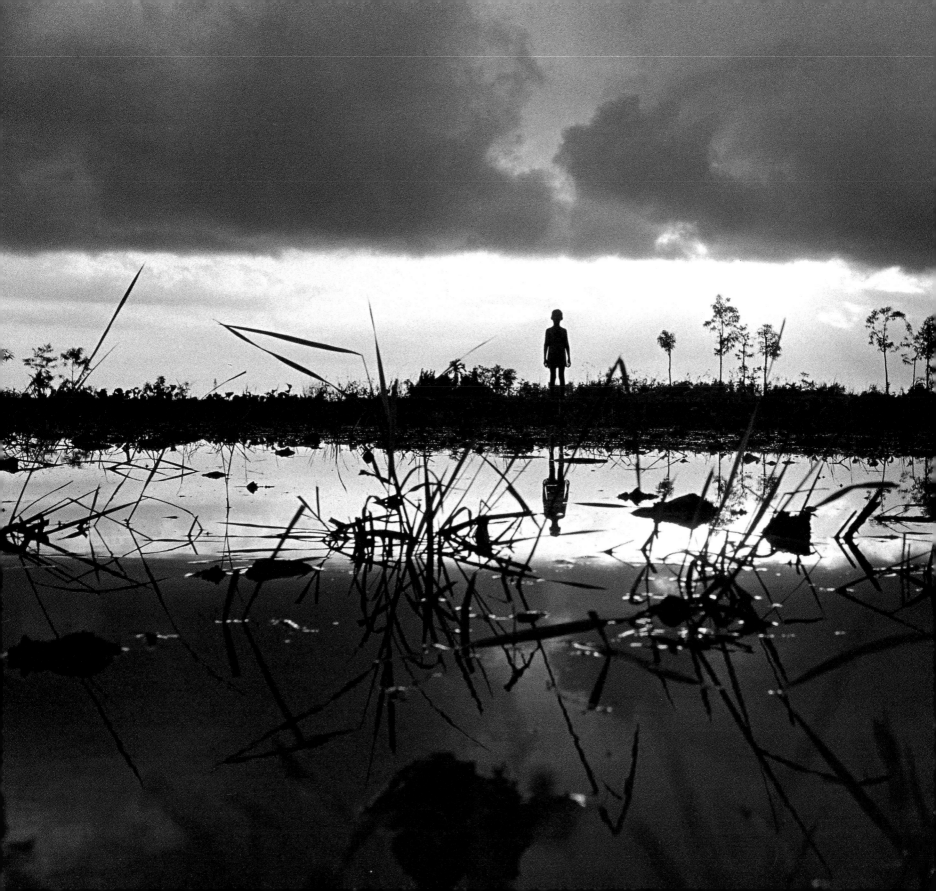

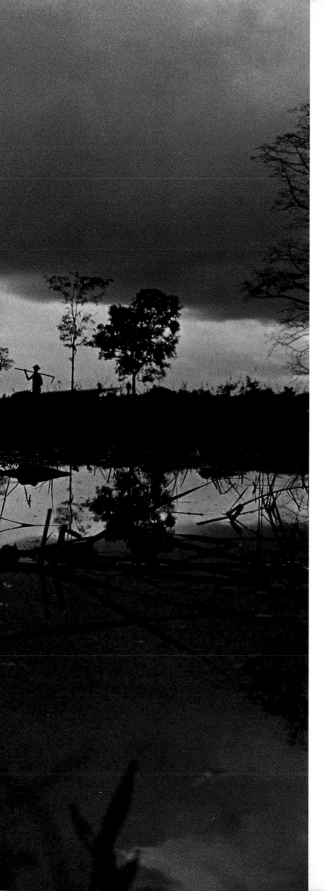

BALI 1969

'Prohibited from Entry:' warns the Indonesian Customs and Excise Declaration we filled in on the plane, 'weapons, narcotics, pornography (without special licence).' They need not worry. This is one of the last countries on earth where one needs pornography.

There are few places to which I would really be happy to return by the next plane from London, after having flown more than 8,000 miles from it in twenty-four hours, but Bali is one of them. I cried on my last morning there – in private of course – simply because I knew that the chances of my going back there were extremely remote. Even before one arrived, flying over Java and looking down from 28,000 feet or so into the enormous, reeking maws of 10,000 ft-high volcanoes, one of them with a blue lake hidden in it, I was sure that I was on the way to something extraordinary, which even the let-down of Bali airport (which is just like any other airport, set in a huge expanse of gravel) failed to dispel.

In spite of what people who knew it before the war and after say, In 1969, Bali still had an extraordinary, vernal atmosphere which comes from the people who inhabit it rather than the place itself.

The island is beautiful, but it is no more entrancing than some other places in the East. There are other wild shores equally or even more lovely, on the coasts of Malabar and Coromandel. There are no great, lost cities, buried for centuries in the jungle, such as Ankor Wat or Gaur in southern India, and even the biggest of the temples is not as stupefyingly large as that of Borobodur, the Buddhist shrine across the narrow straits in Java, or as extravagant as Konorak, hidden away in the sands on the shore of the Bay of Bengal.

LEFT Paddy field, Bali

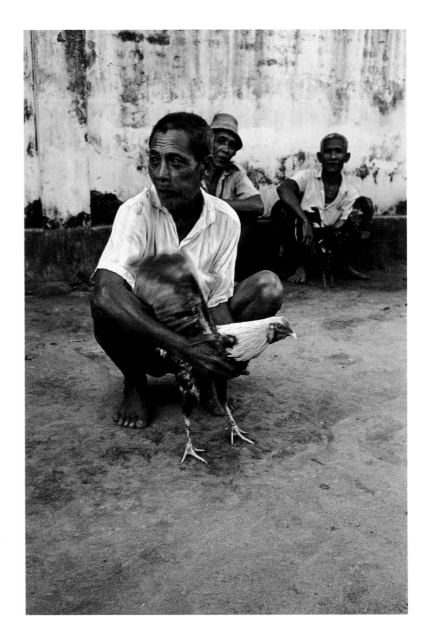

Large man in a café, Indonesia

Fighting cocks, Bali

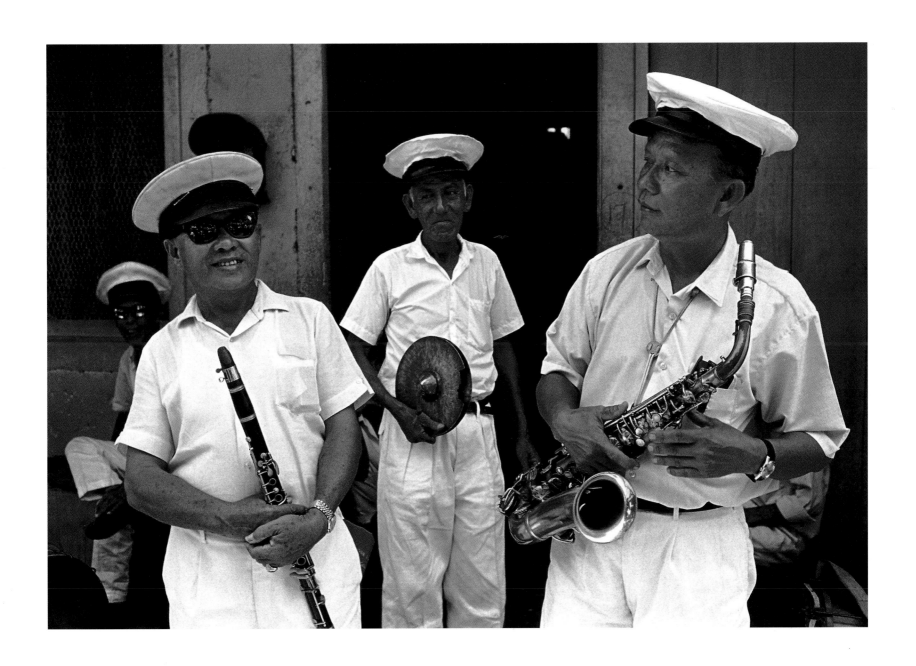

Musicians in a band, Indonesia

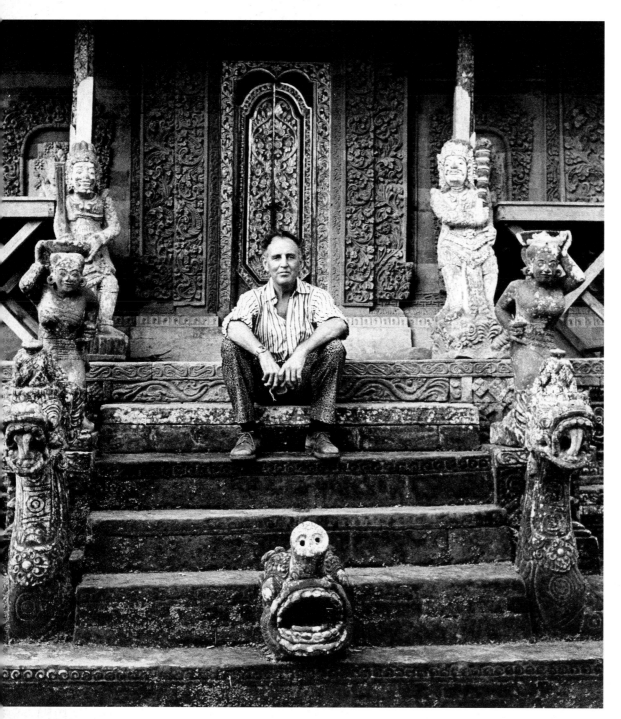

THE AUTHOR ON THE STEPS OF A TEMPLE

Bali is about twenty times the size of the Isle of Wight and much the same shape, but there the resemblance ends. There are said to be 10,000 temples in Bali and there may be many more, for every house has a shrine and many of them are large enough to qualify as temples. They were less frequented than those in India, the little doors of the tabernacles were mostly shut in the day time, and less creepy. Here, as well as in the temples, offerings are made – in the dust of the road, on the floor of a shop, in the narrowest part of a bazaar – a rectangle of plaited leaf with marigolds and other flowers on it. Even a great cave in the interior, with a monster carved over the entrance which seems to be splitting the rock in two, has none of the eerie dottiness, of the cave in *A Passage to India*, no bats, only a passive statue of the elephant god in a niche inside, waiting for someone to illuminate him momentarily with a gas lighter.

It is the human beings that are so beautiful in Bali, so small, so finely made. To them a European man or woman of five feet nine or ten must resemble a Goliath. Not all the women are beautiful, but they carry such immense weights on their heads, and have to stand so upright to do so, that one wonders that they do not sink into the earth. This gives them an immense grace and splendour even when they are carrying nothing but themselves.

You would have to be a person with a heart of stone to ignore the people in this land, or stone deaf, for this is (or was) a place of constant greeting. Any visitor with feeling will be constrained to memorise one or two greetings or farewells in the language to use along the road, but employing them you will not get the enthusiastic response that you might expect. The universal greeting here between visitors and visited is 'Ullo!,' to which you must reply; no other response gives such universal pleasure. But you are 'ulloed' by delicious girls who would roar for help if you 'ulloed' them up the junction, by small boys high up in the rigging of fruit trees, from the bottom of wells, and by cohorts of potbellied infants just off the breast, standing in doorways. Difficult to believe that terrible atrocities happen here.

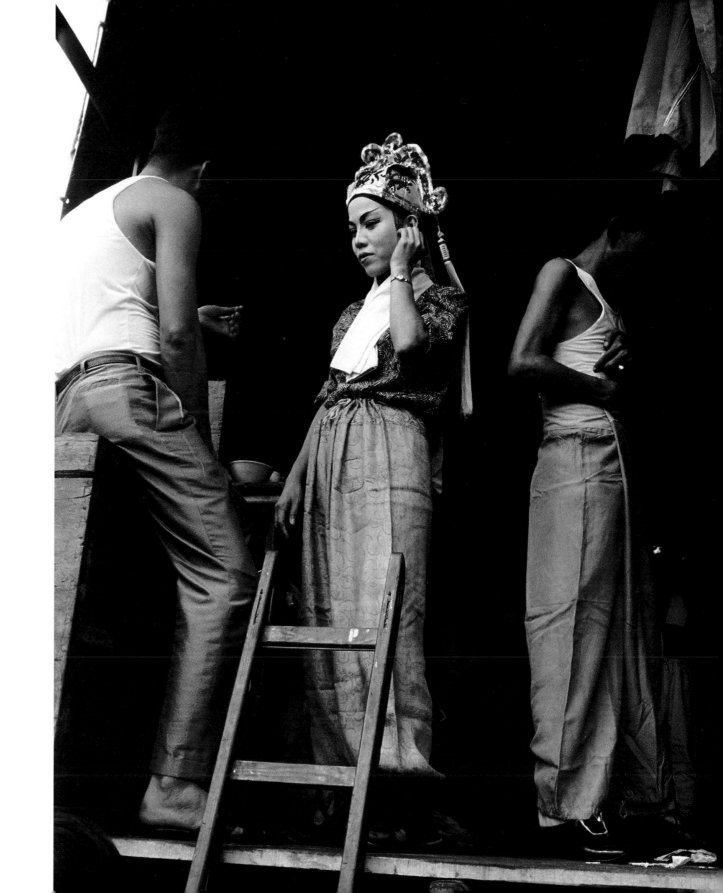

Preparing to dance the *Legong*
a famous Balinese dance

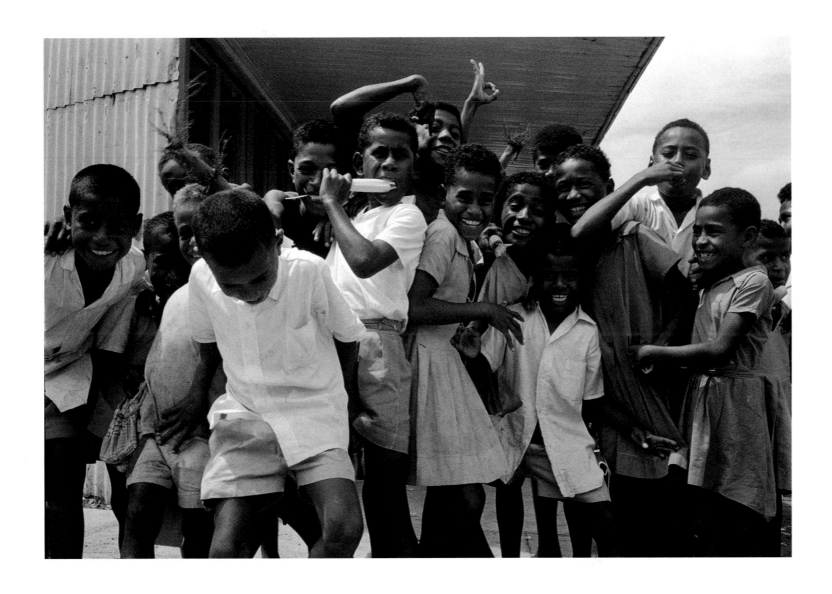

OPPOSITE Decorating a church, Goa

Little Fijiana happily oblivious to an uncertain future

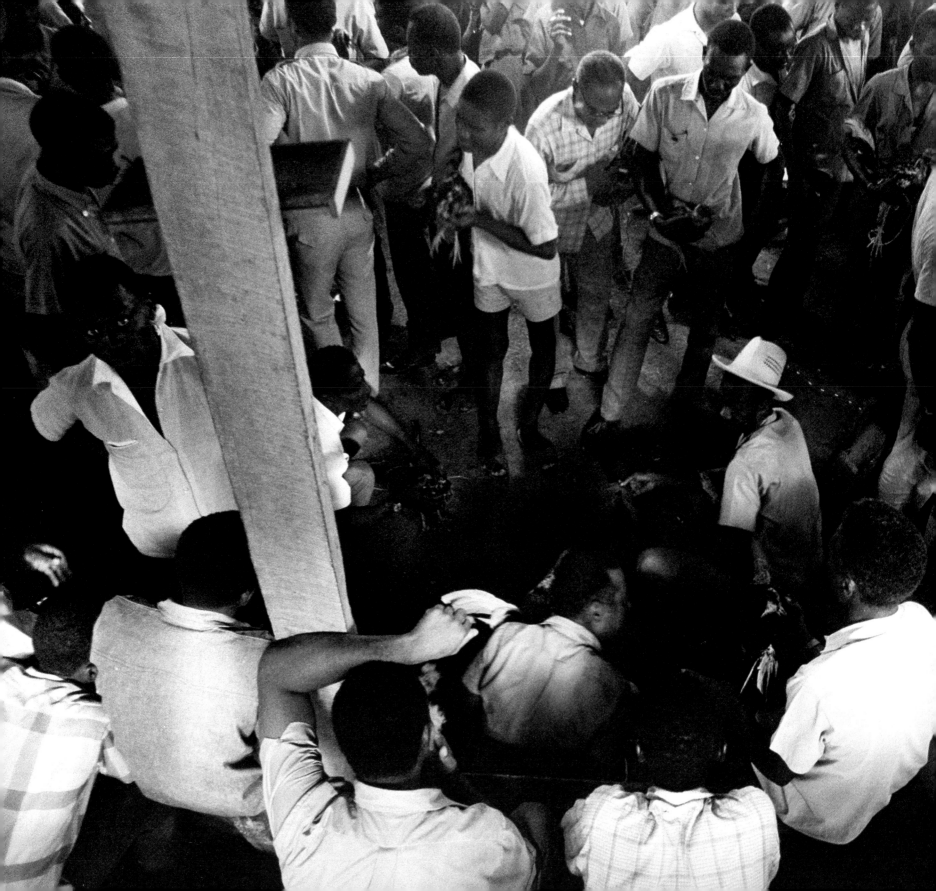

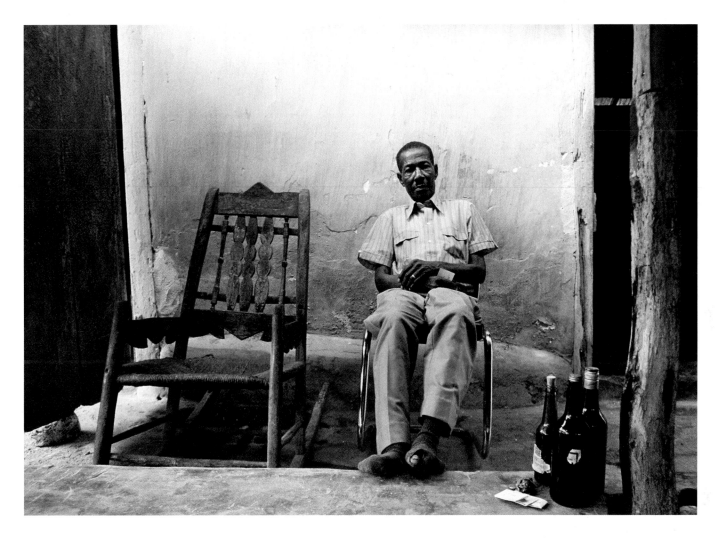

A HOUNGAN OR VOODOO PRIEST,
PORT-AU-PRINCE, HAITI

Although it was the close season for voodoo, we visited one of the tonnelles (shrines) on the outskirts of the city. Our guide was a Houngan, a tall, thin, praeternaturally intelligent-looking man who spoke only Creole. In the huts round about, there were altars and all the complex apparatus of voodoo: bottles filled with strange substances, swords, crucifixes, bells and anthropomorphic paintings of gods and goddesses. There were gourds enclosed in beads and vertebrae, china pots that looked as if they ought to have contained foie gras, also tied up with beads, pincers, iron serpents, old bedsteads, and on the walls, mystical patterns and pictures of the Virgin and the Saints.

In the smallest hut, the Caye Zombi, there were shackles and whips. And of course, there was the complete equipment of The Baron, set out like a gentleman's wardrobe for the day, but on a black cross. It was all very interesting, but it needed the ecstatic participants in the ritual to give it any meaning.

OPPOSITE Cockfight, Goa

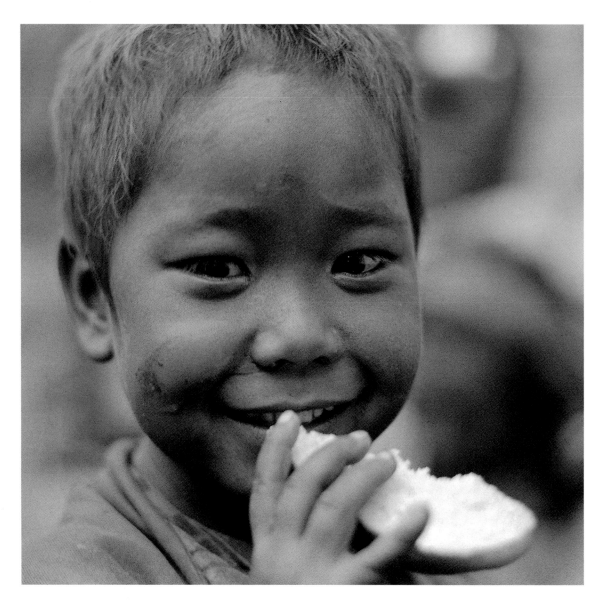

Gond boy, one of the aboriginal people living in a clearing in the jungle near the banks of the Gondaveri River, Andhra Pradesh formerly the state of Hyderabad, before the Nizam was shorn of his powers in 1948. Near his village, a tiger had killed a water buffalo three nights previously. Here people were apprehensive of wild animals. In the fields at night, which falls rapidly, watchmen sat in little *machans* (watchtowers) to see that the wild pig and the bison did not damage the crops. They sat in them all night, from sunset till dawn, with a little fire in a pot for company, alternately groaning and striking some metal object in the hope of frightening the beasts away.

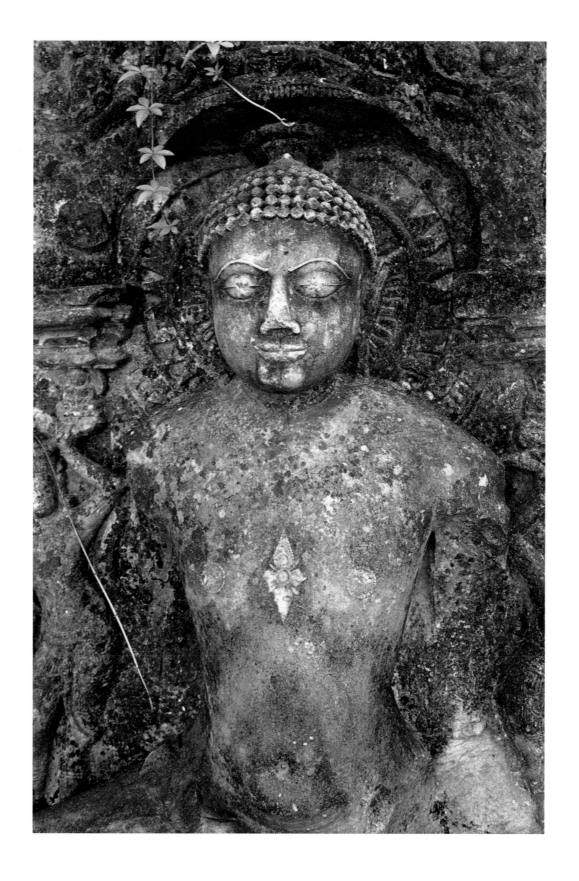

Deity

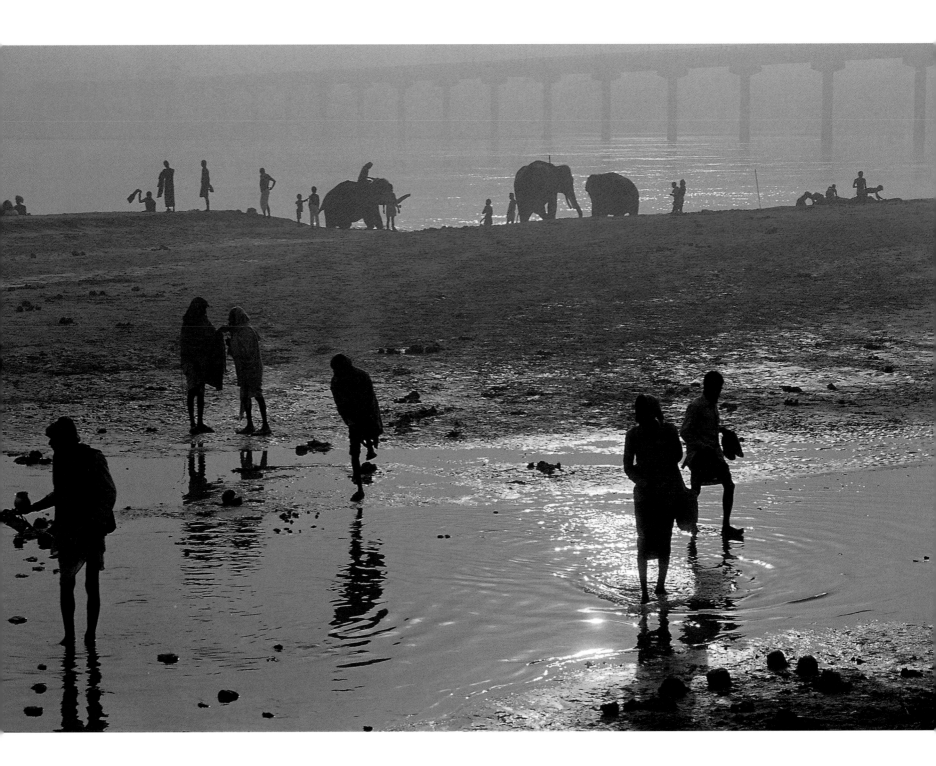

In and about them the day-to day activities of the inhabitants make a timeless, ageless scene. The long pendant branches of banyan trees growing on the banks, overhang the water casting a deep shadow, turning it to the colour of greengages. *Sadhus* and small boys perch in niches in the bank, the *sadhus* immobile, looking like mummified corpses, the small boys happily fishing.

On the bank above, spindle-shanked men run rather than walk as such men always do in India, with bamboos slung across their shoulders, heavy earthenware pots suspended from them at either end. Sometimes they are carrying corpses wrapped in white cloths to the burning places, or crying 'Rim Nam Sat Hai,' (the Name of God is Truth) accompanied by another who carries a pot with fire in it to kindle the pyre.

In the river, near a shrine in which the platform from which a black linga rises is decked with fresh marigolds, some white-clad figures perform their *pujas* and women and girls wallop the washing on lumps of brickwork, all that remains of some Moghul palace or gazebo, and shout to one another in coarse cheerful voices. There are ruins everywhere: red sandstone temples, their spires carved with figures of men and animals and gods, but still in use, and the even more ruined remains of secular Muslim buildings and mosques. All of them, overgrown with vegetation and reeking of the sickly smell of bat dung, stand incongruously among the groves of mangoes, clumps of palms, plantations of castor oil trees, fields of bushy-topped millet and wheat and sugar-cane: the immense, horizonless agricultural country of Uttar Pradesh, in which the peasant's plough still turns up tiles, coins and broken pieces of sculpture, testifying to the transience of civilisations.

For many miles downstream from Hardwar a boat is a comparative rarity. But here there are more ferries loaded with men and bicycles and goats. And there are boats going down under sail, running before the wind, sometimes lashed together in pairs with one ragged square sail set on a communal yard.

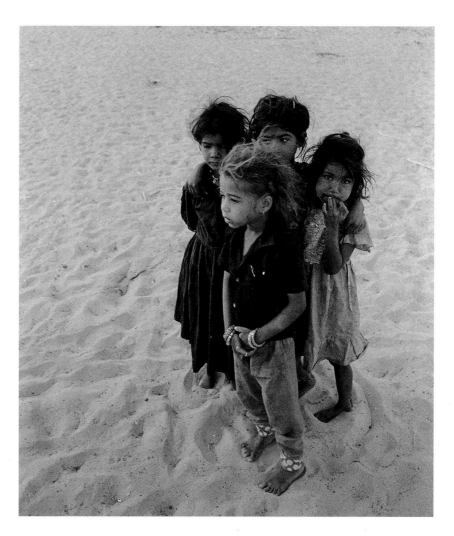

Children at camel fair, Pushkar, Rajasthan

OPPOSITE Elephant fair at Sonepur, India – early morning ablutions

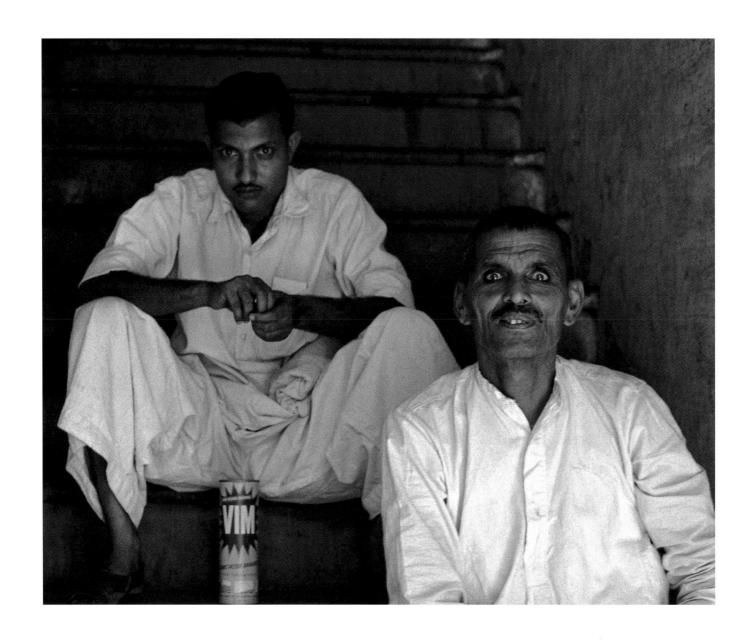

Indian cleaners using Vim

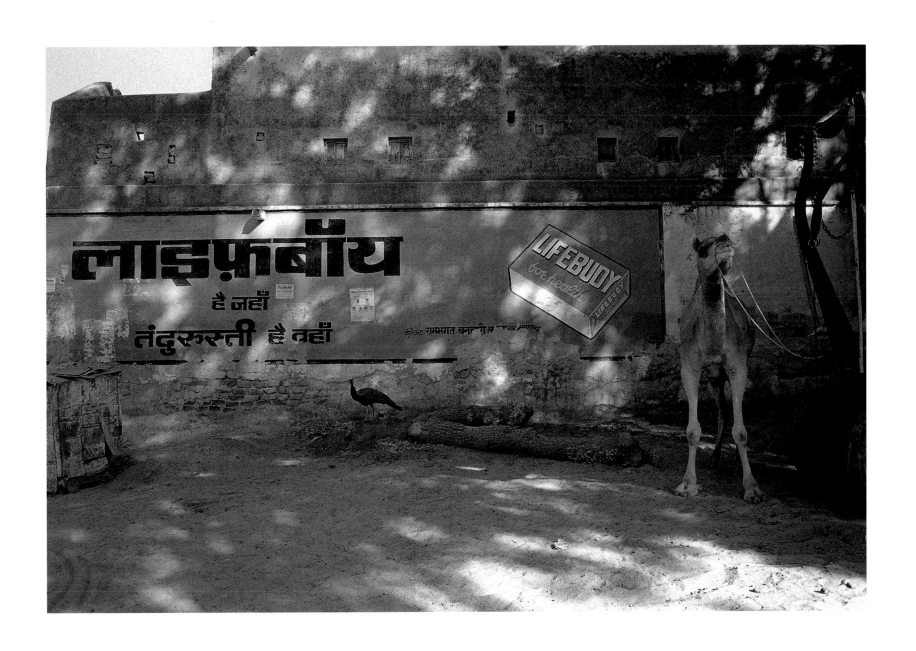

Camel and peacock at Pushkar, Rajasthan

OPPOSITE All the human frame requires. . .

Two ways of reducing the population,
and other signs, in Patna

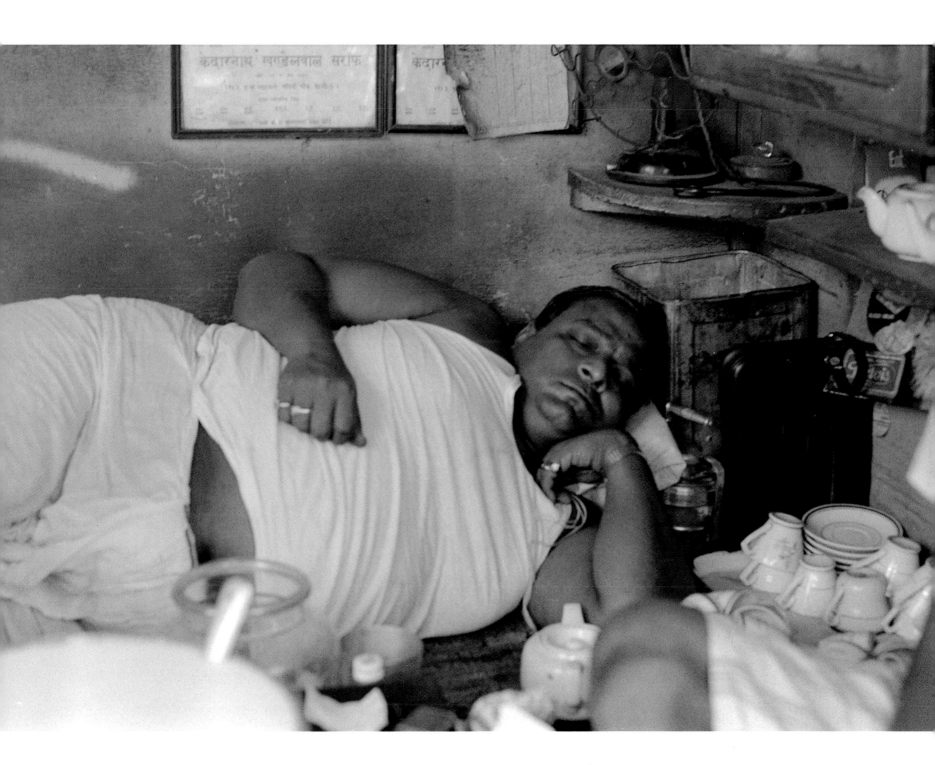

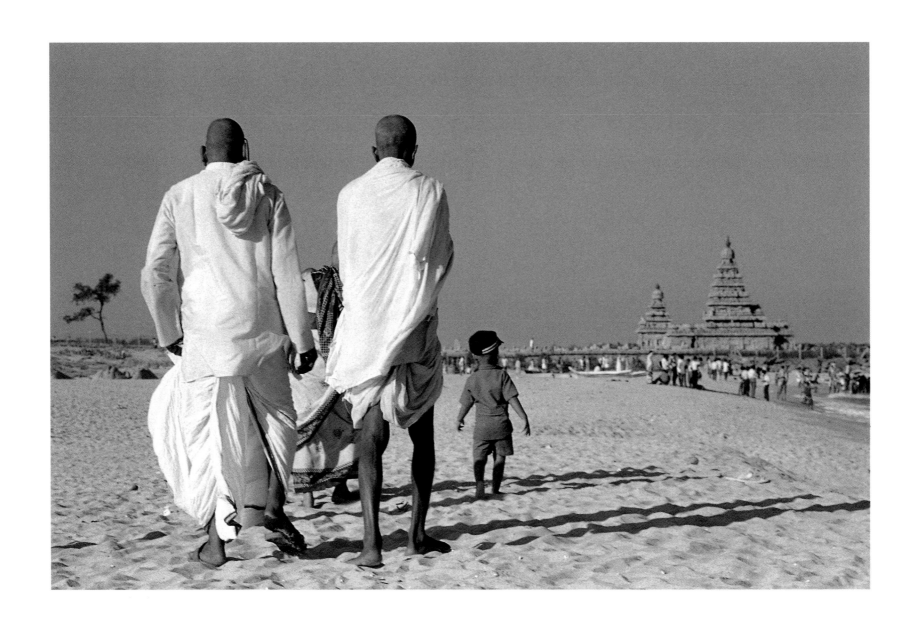

Devotees approaching the temple by the sea at
Mahabalipuram, on the south-east coast of India.

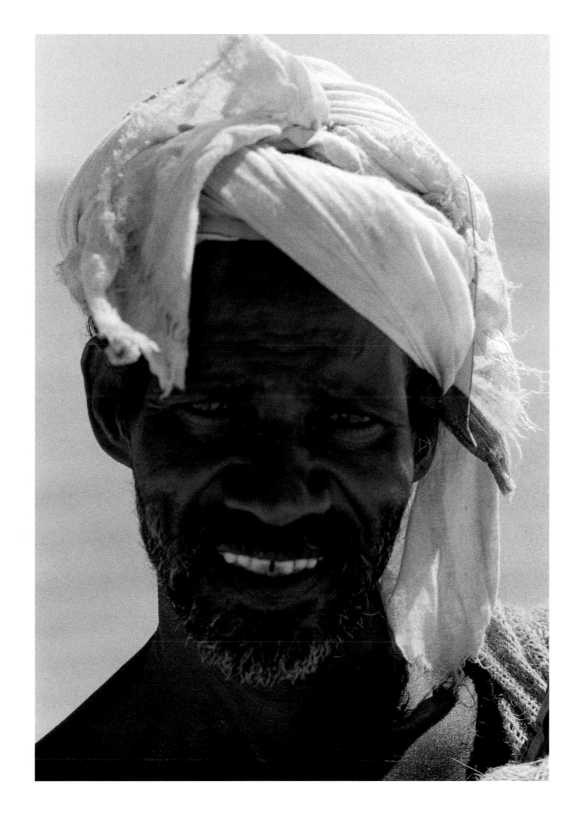

A fisherman at Mahabalipuram

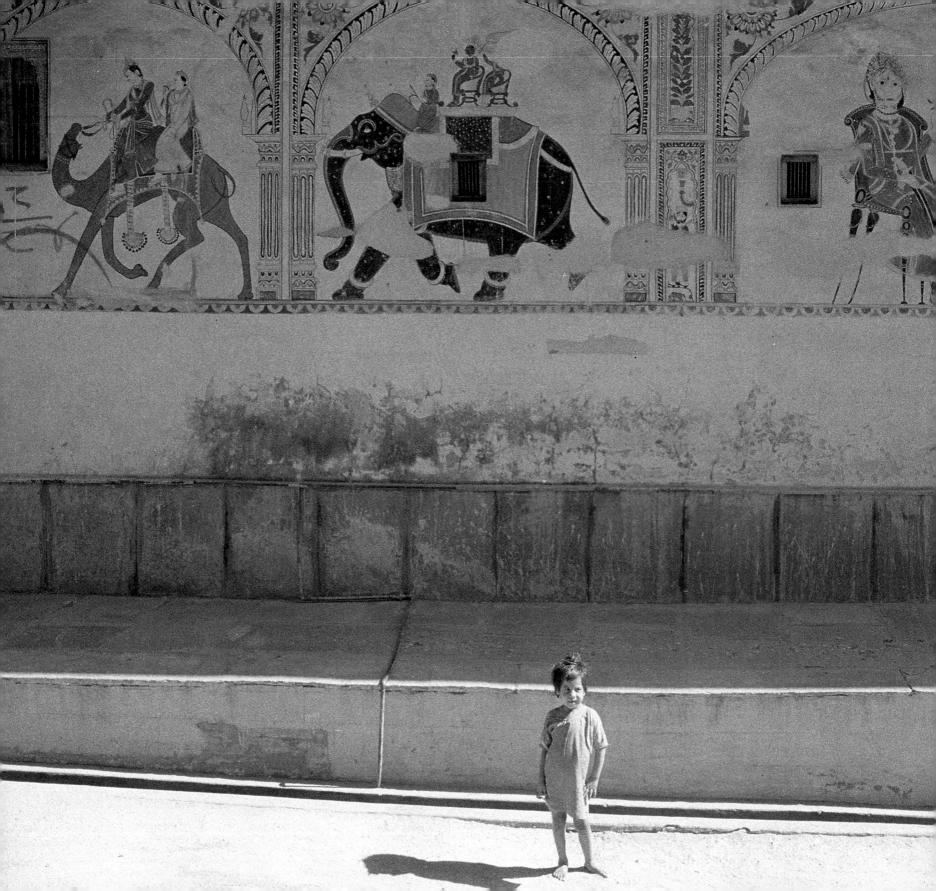

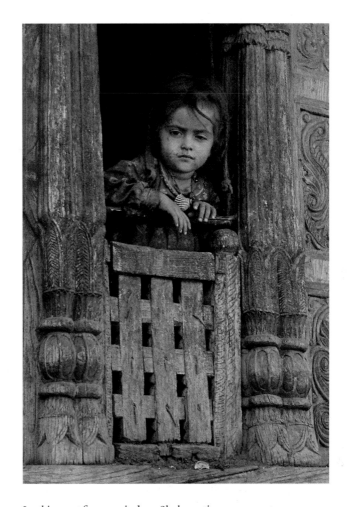

Looking out from a window, Shakravati

LEFT Shakravati – Wall paintings

153

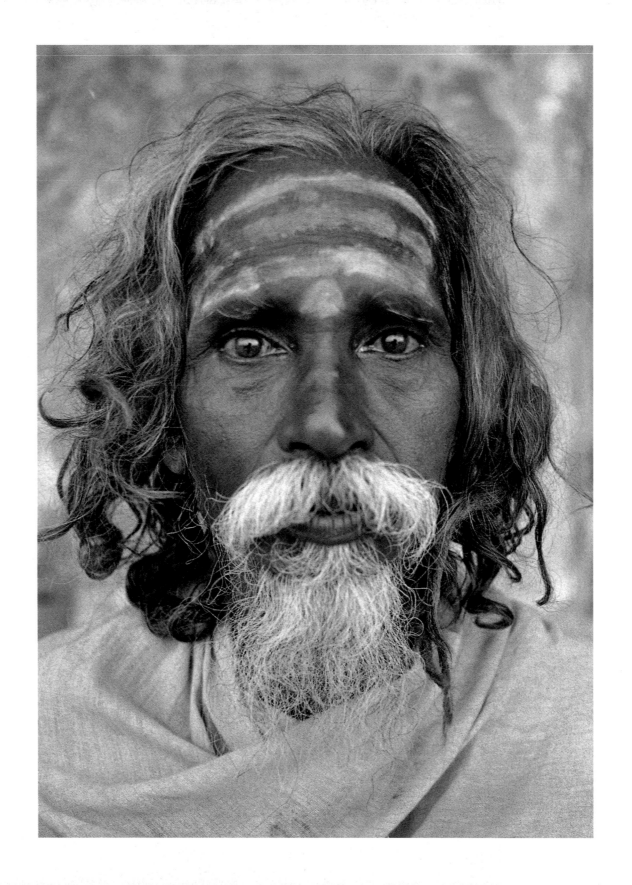

Sadhu, holyman

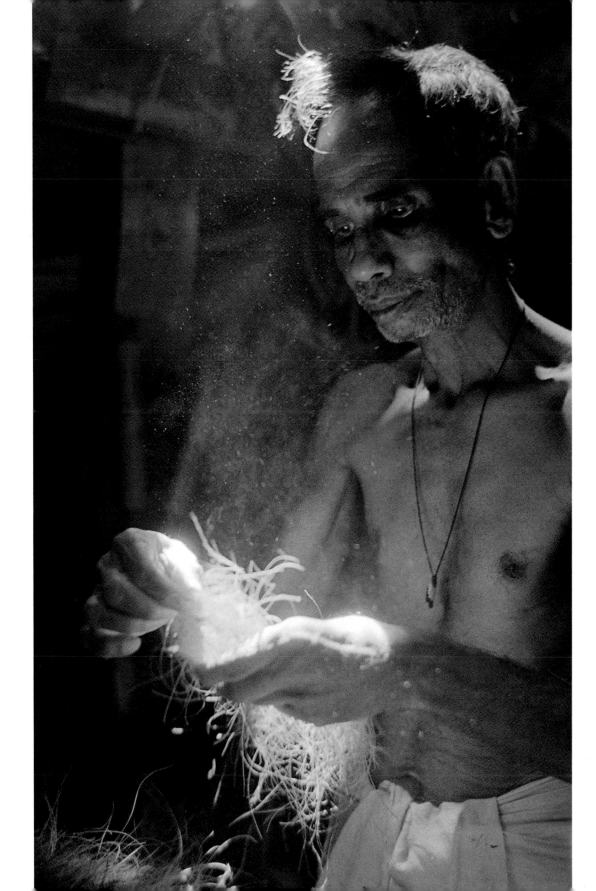

Barber performing a ritual haircut at the Kumbh
Mela Allahabad. The pilgrims at Allahabad had
all been shaven with varying degrees of severity,
in the barbers' quarter: Women from the south
and widows had their heads completely shaven;
men were left with their *chhotis*, the small tufts
on the backs of their skulls, and those who had
moustaches but whose fathers were still alive,
had been allowed to retain them; natives of
Allahabad were allowed to keep their hair;
Sikhs gave up a ritual lock or two. At one time,
the hair was buried on the shore of the river;
now it was taken away and consigned to a deep
part of the Ganges, downstream.

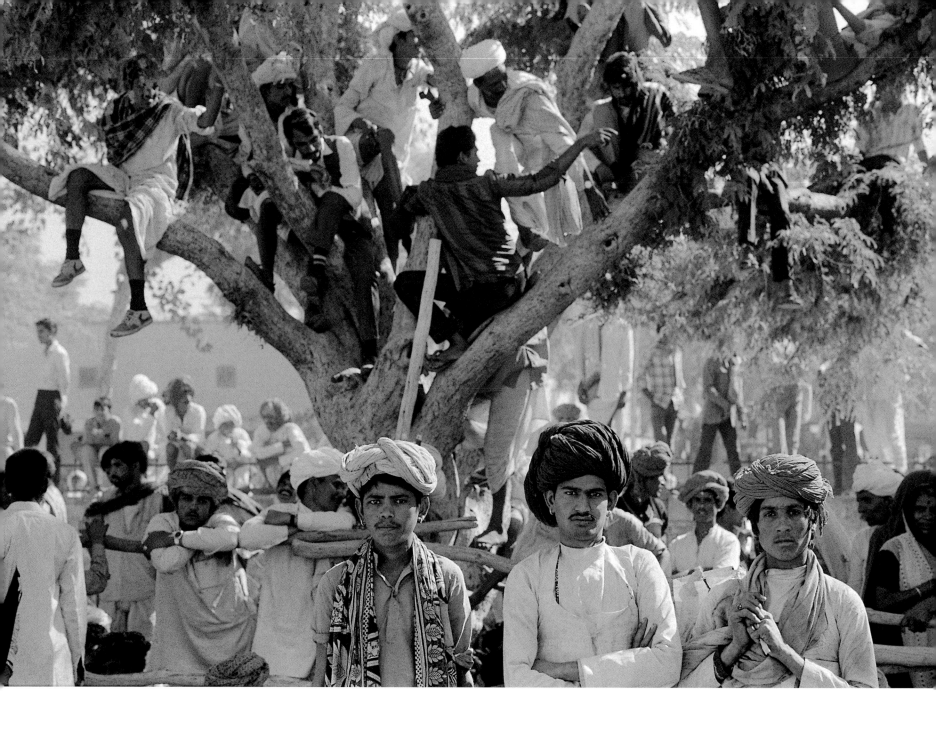

Spectators up a tree at the elephant fair, Sonepur

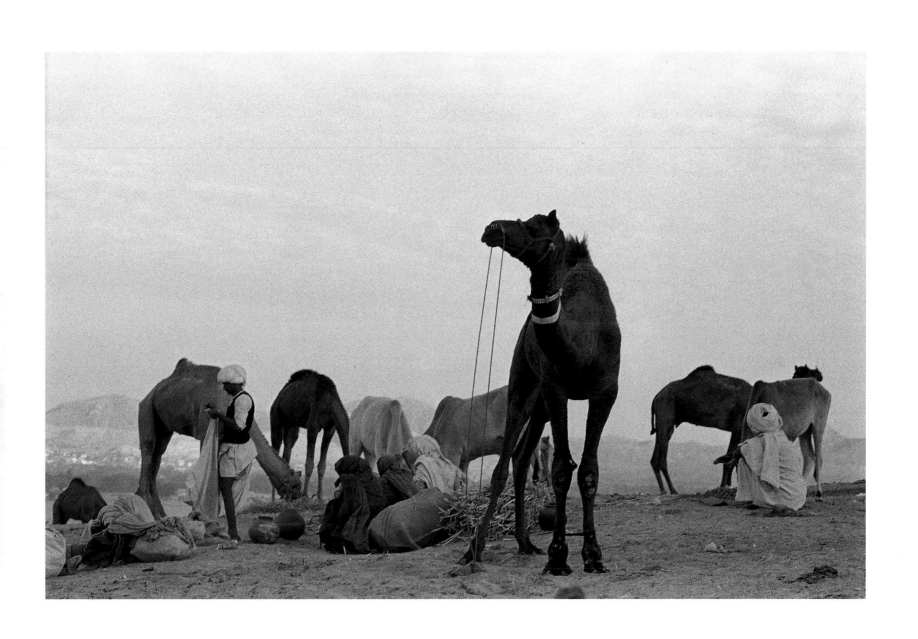

Camel fair at Pushkar, Rajasthan

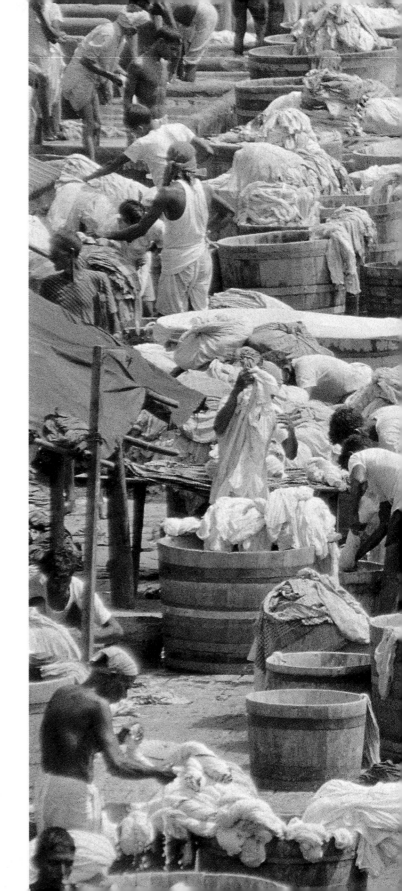

Dhobis (laundrymen and women) Patna,
one of India's toughest places

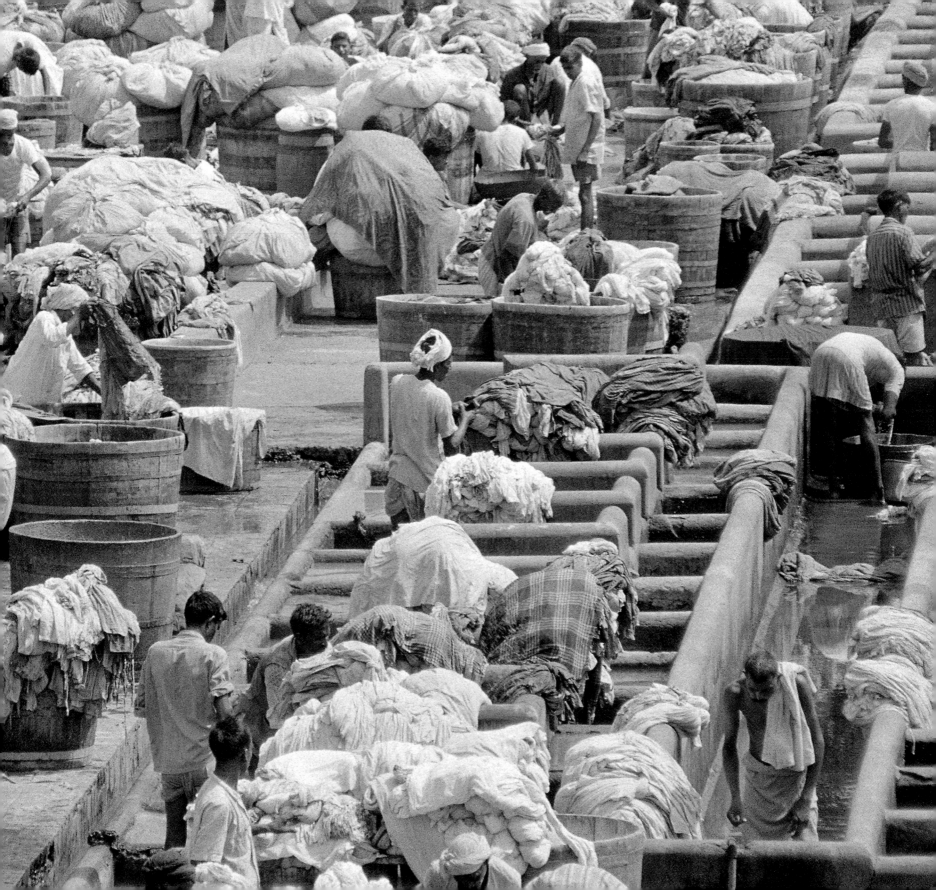

Girl behind a weaving loom in Portugal

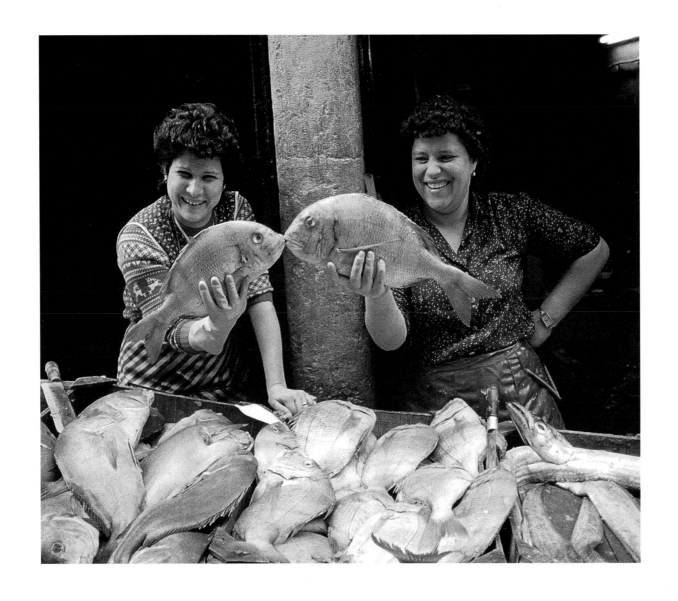

Portugese *varinhas* (fishwives)

OPPOSITE *Varinhas* from Angola and
Mozambique, Lisbon, picking up the catch

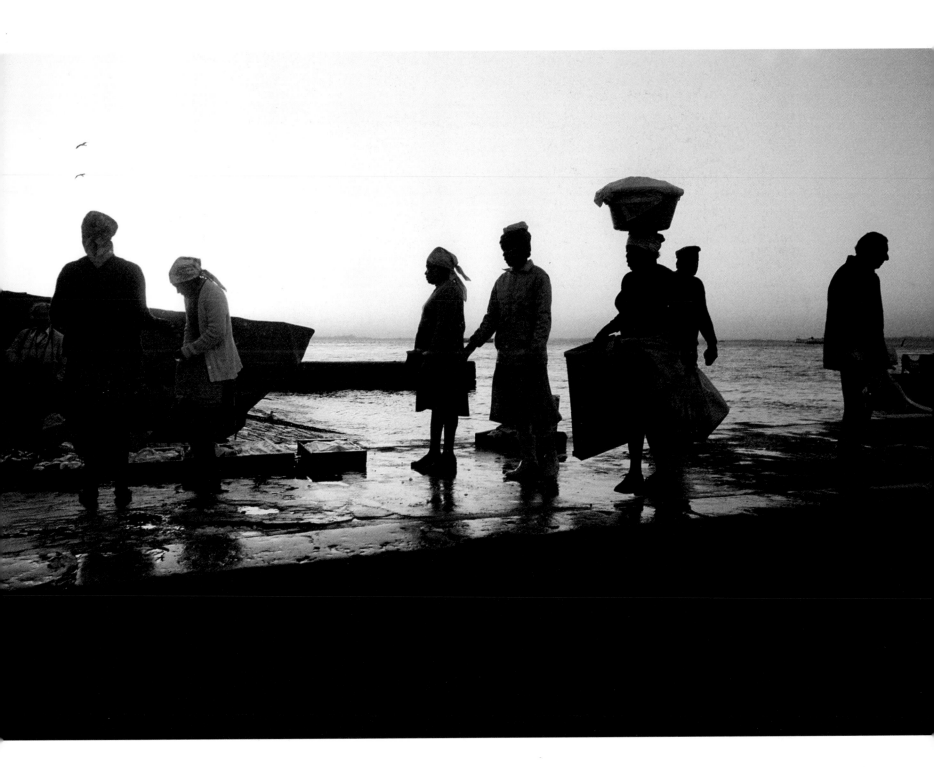

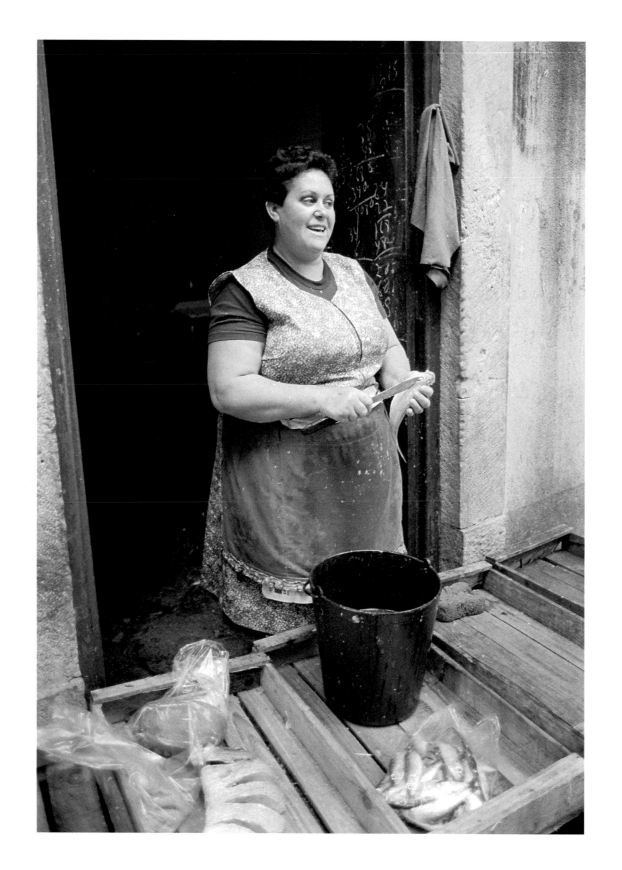

A *Varinha* preparing fish for sale, Lisbon

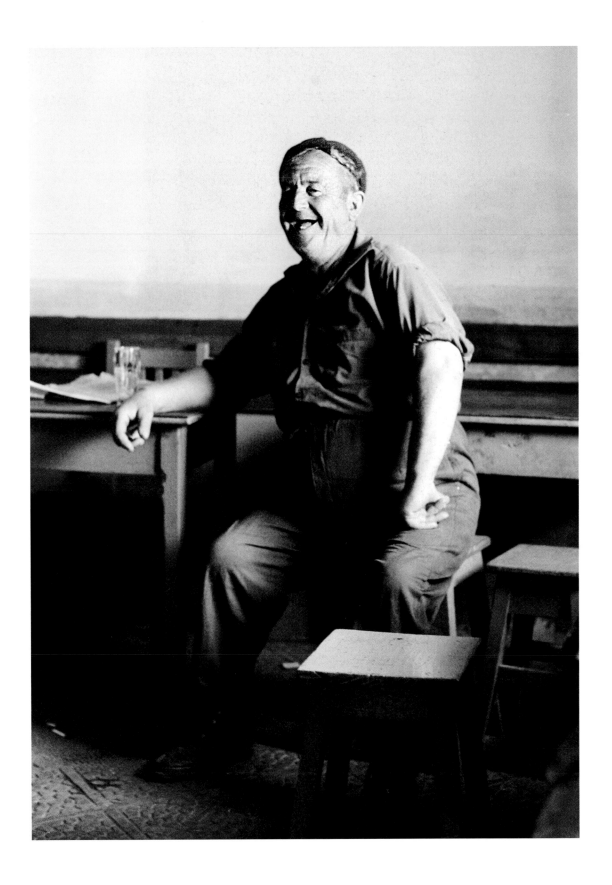

Man in a bar, Lisbon

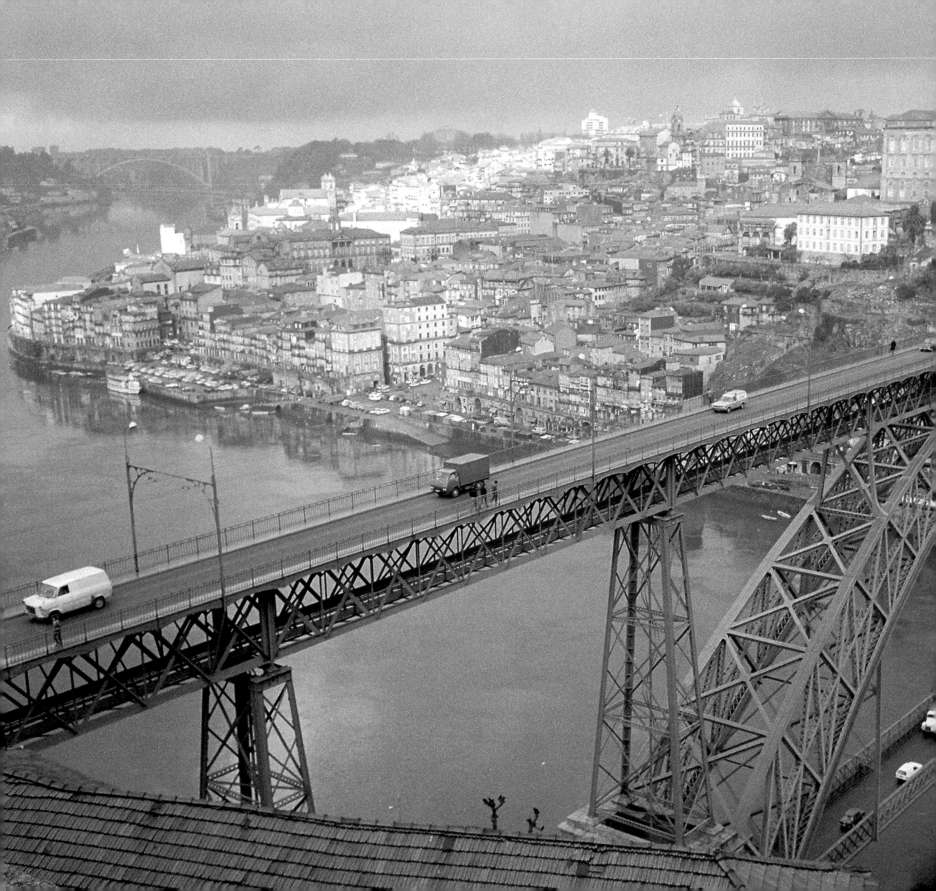

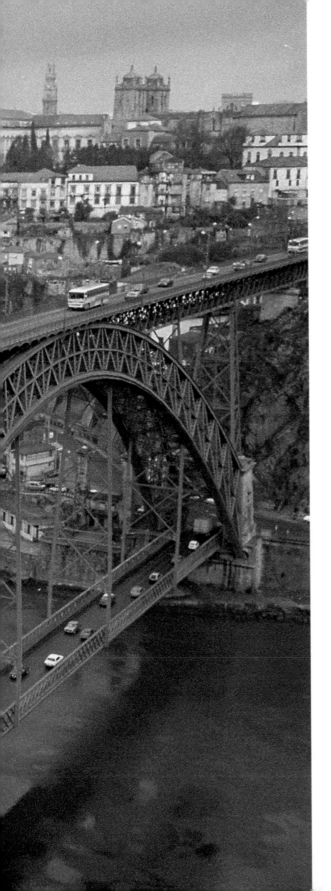

The great bridge of Gustave Eiffel (1832–1923) at
Oporto; a 560 foot arch spanning a gorge of the River
Douro. Eiffel also designed the railway bridge of Dona
Maria (1876–77). Another monument to the engineer
is the *elevador* in Lisbon, which links the upper and
lower towns. Alexander Gustave Eiffel was a French
engineer born at Dijon. A great bridge builder, he also
designed the armature for the Statue of Liberty and
the Eiffel Tower, built for the Paris Exposition of 1900,
largely at his own expense. Eiffel became involved in
the Panama Canal scheme and received a two-year
prison sentence and a 20,000 franc fine, but
surmounted these obstacles and remained honoured.

167

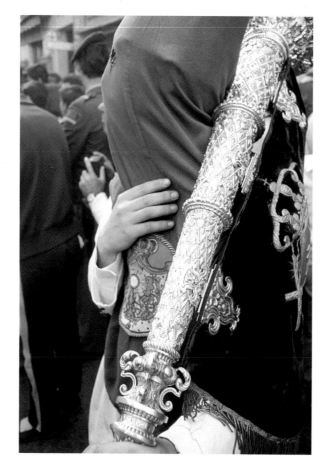

A PENITENT IN SEMANA SANTA
(HOLY WEEK) SEVILLE, 1984

During Holy Week in Seville we had seen at least part, in
some cases the major part, of fifty-two processions. None
had lasted for less than four hours. The longest, *La Macarena*,
had lasted twelve and a half hours.

Night and day except for an hour or so after midday, the
great floats – all of them enormously heavy – embellished with
silver, some decorated with flowers and bearing sumptuously
dressed figures of the Virgin (the floats and figures of
inestimable value, a Virgin's clothing and accessories alone
valued at £100,000), other effigies depicting events in the last
six days of the life of Christ, had swayed through the streets,
those of the Virgins like great ships illuminated by masses of
candles, all born on the backs of hordes of sweating porters
invisible beneath the velvet draperies, some macabre, some
beautiful, some very old, some made as late as the 1970s.

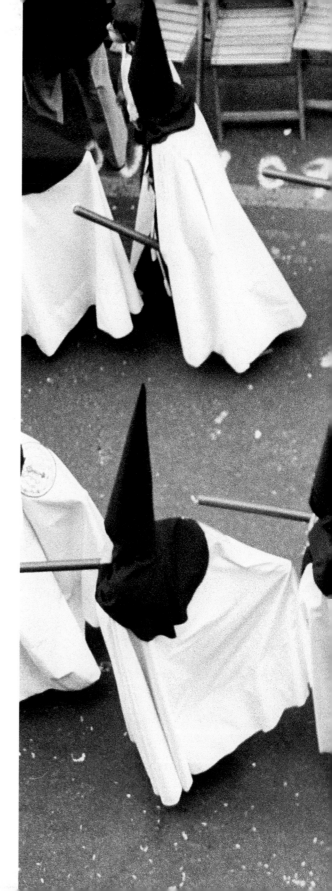

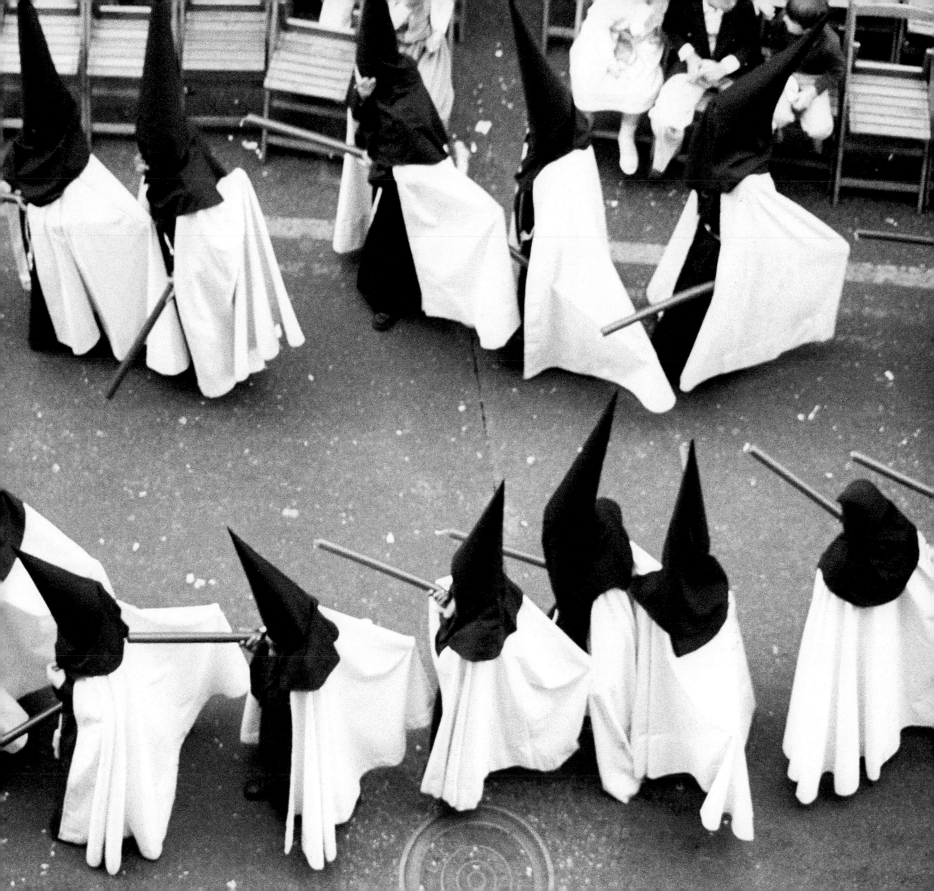

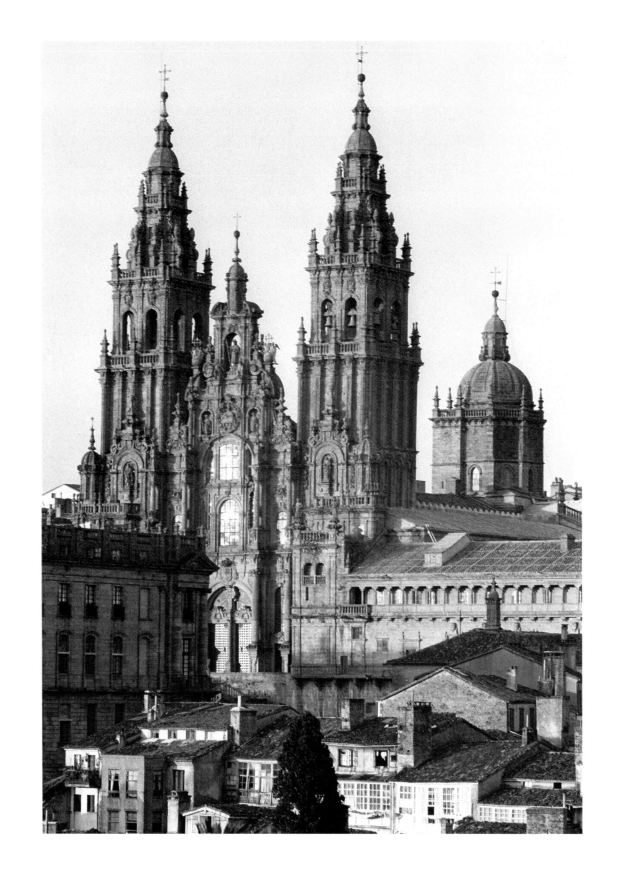

The Cathedral of Santiago
de Compostela

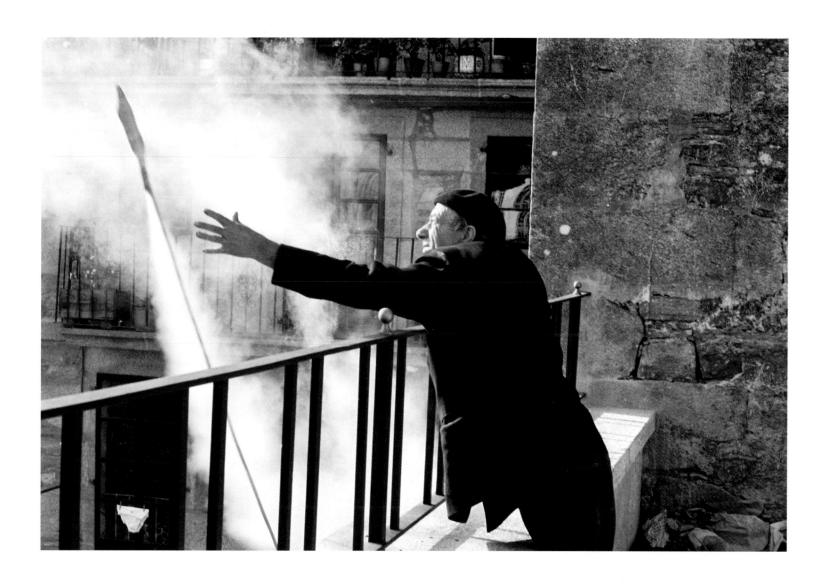

Here, the custodian is letting fire a premonitory rocket to mark the recommencement of the swinging of El Botafumeiro, the giant censer which was first hung and swung in 1602 in the Cathedral of Santiago de Compostela, brilliantly described by Walter Starkie (1894–1976) in *The Road to Santiago* (1957).

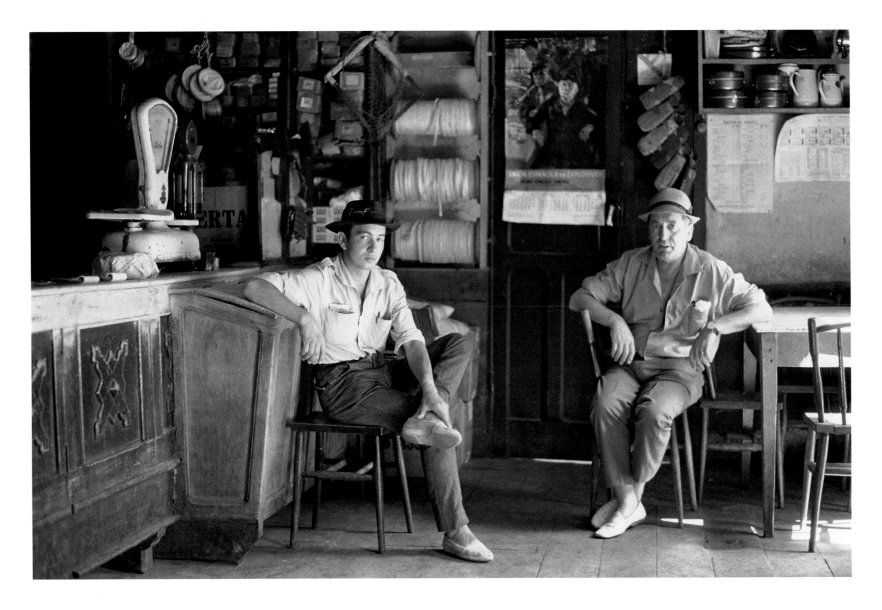

MEN IN A CAFÉ, PICOS DE EUROPA, 1965

The Picos de Europa are in the mountainous area on the borders of Santander, Asturias and Leon. The actual place where the provinces meet is on the 7, 710 ft Pico Tesorero right in the middle of the massif. The peaks rise in pale clusters like giant funghi. The are not particularly high, but they are exceptionally sheer.

The inhabitants existed in an isolation which was rare in the West. Even then, the region was in danger of being turned into just another Dolomite, and the roads were planned up the steep valleys of Sotres, and a *telférico* was already under construction. Soon a way of life was to disappear for ever.

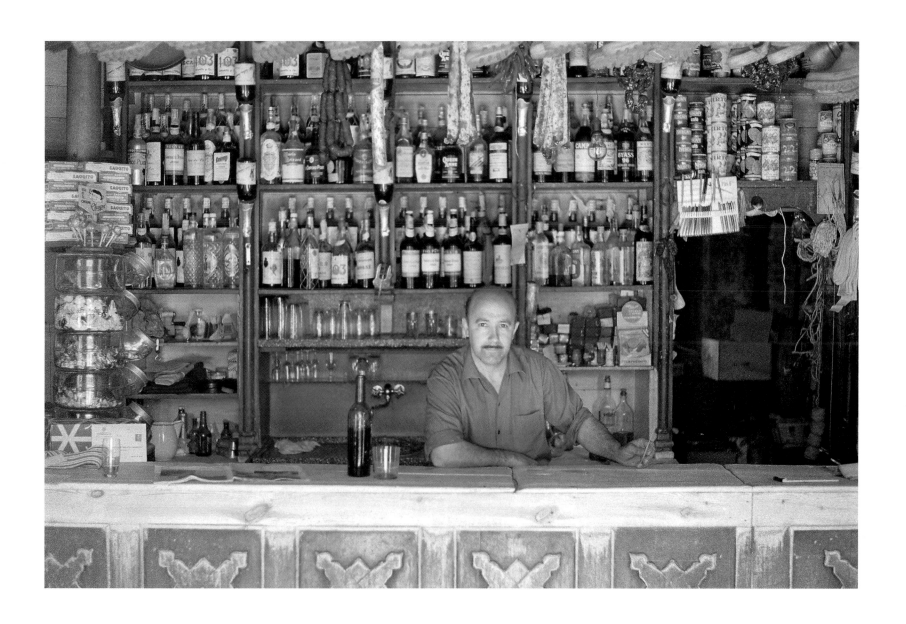

Bar on the waterfront, Lisbon

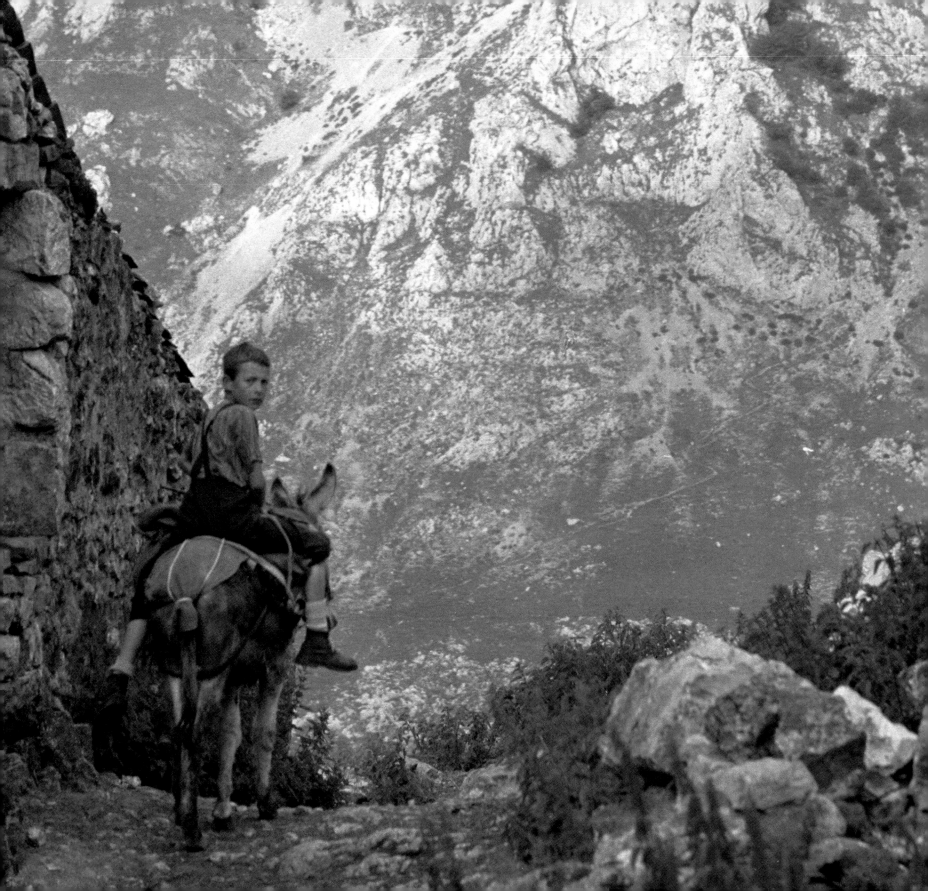

OPPOSITE Boy on a donkey, in the Picos
de Europa, Northern Spain, 1965

Gypsies on the road to Galicia, 1965

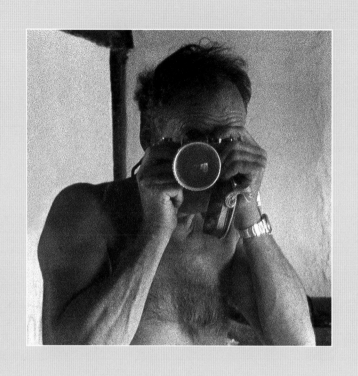